House of Print

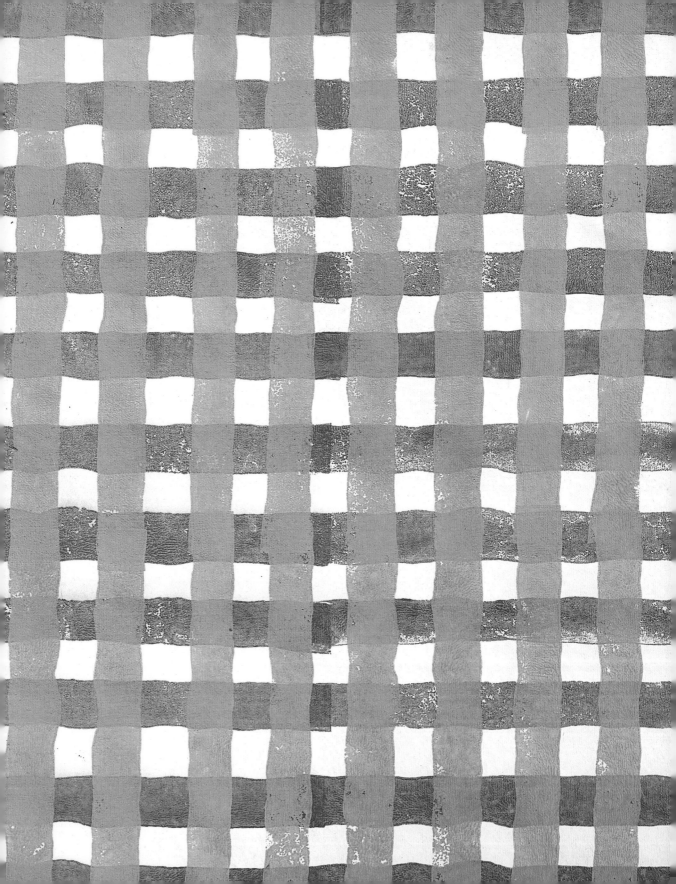

House of Print

A modern block printer's take
on design, colour and pattern

Molly Mahon

Photography by Kristin Perers

PAVILION

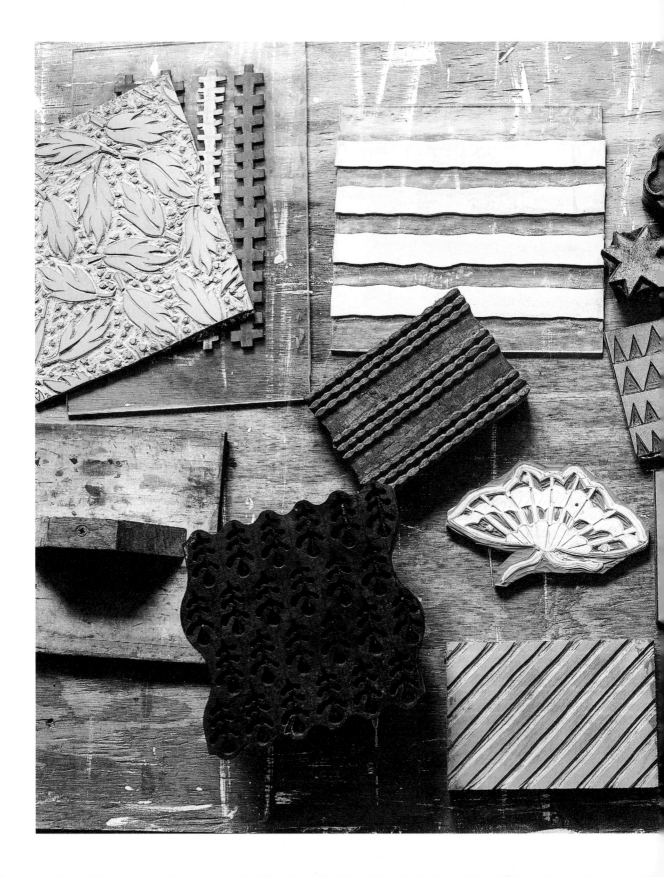

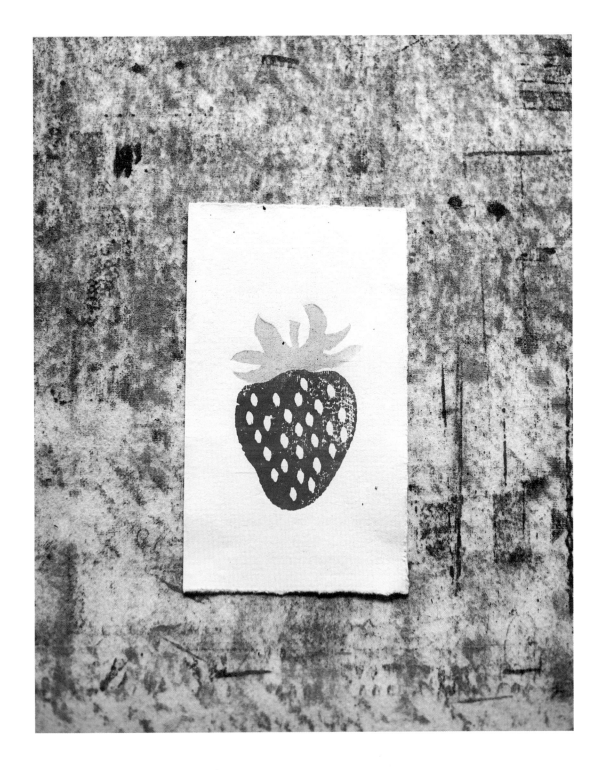

A JOURNEY THROUGH PATTERN AND COLOUR

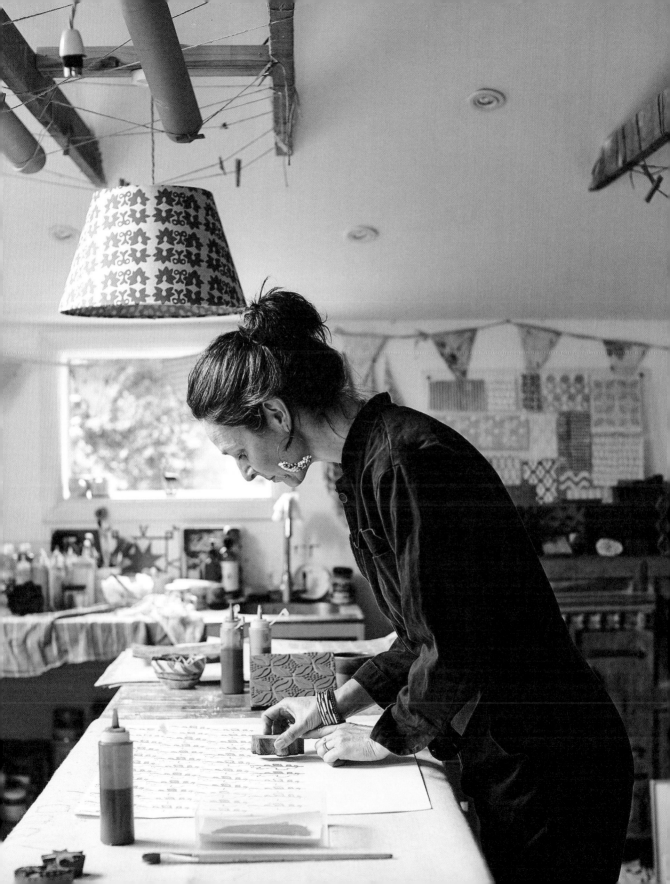

My home is so important to me. It's the place where I spend much of my time, the place where my children are going to make memories, and the place where we like to unwind, relax, entertain and create. For me, it's crucial that the elements of our home (the things we choose to have around us) make us feel happy. Like a fresh vase of flowers cut in the spring dew, or a newly made bed with crisp linen sheets, a hand-printed cushion or some block-printed curtains add to the 'joy' in my home.

I can express myself using pattern and colour much more easily than I can with words. I think our homes should speak of ourselves – of our experiences, desires and passions. Through the art of block print, I have found I can add personal and unique pieces to my home that do just that. From lampshades and stationery to tea towels and tableware, each element, in its own quiet way, enhances our lives and makes us smile.

This book is my love letter to block print. In it I share the inspiration behind my work and show you how to imbue your house with the joy of homespun pieces. I want this book to encourage you to clear your kitchen table, roll up your sleeves and get printing – perhaps you might even become as obsessed with it as I am! Most of all, I hope it ignites your creativity and opens your eyes to the beauty of this wonderful craft.

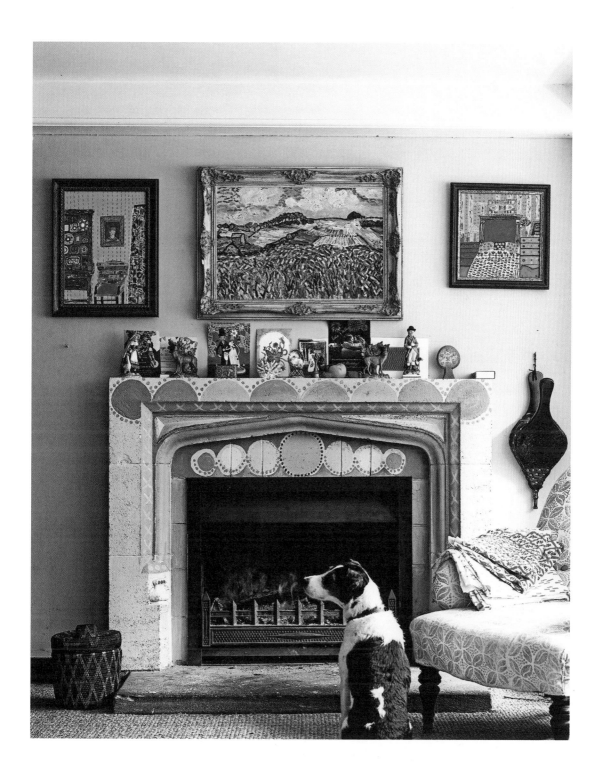

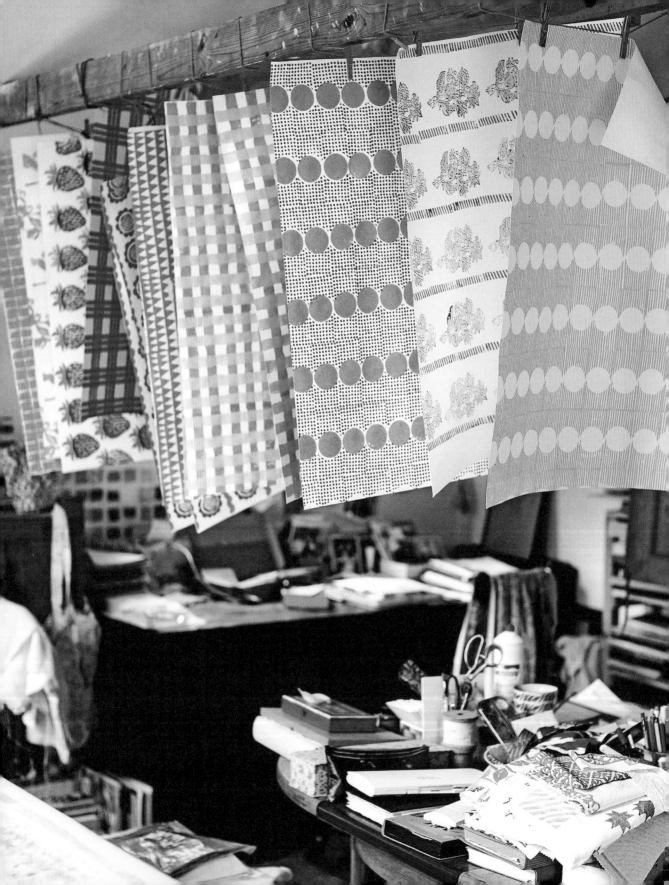

A MODERN BLOCK PRINTER

I live nestled down a bumpy track in the midst of the Ashdown Forest in East Sussex. My life rolls with the constant ebb and flow of looking after my three children – Lani, Algie and Orlando – and running my textile and wallpaper business with my husband Rollo. Our home is the heart and anchor of all of these things.

In my early twenties I ran a successful events business while living in London and was used to 'busy'. So when I found myself at home with my first two children (and some precious time to spare at my kitchen table), block printing became something of a passion project for me. Inspired by the bursting shelves of beautiful wooden blocks at a printing course I had attended, I became obsessed with pattern and this wonderful craft, which I could practice and enjoy at home.

Having started out by making a few simple items for my own living room, a small wallpaper order for a shepherd's hut accidentally kick-started my block printing business. Soon the demand for my colourful patterned prints went beyond my family and friends, and I started to take my work to design fairs where sales of my hand-printed stationery and cushions started to grow.

Fuelled by the demand (and on a bit of a whim), I took myself to Jaipur to further my education in the craft. Blown away by the possibility and the sheer joy of the incredible craftsmanship I found there, I connected and started to work with block printers who have been passing down their artisanal skills for generations. To me they were, and still are, the real deal when it comes to pattern making.

I now run my business from a studio in Sussex where we offer fabrics, wallpapers and a growing collection of homewares from our website, our London concession, and in a number of lovely outposts around the world. For me, the business is a portal to share my love of block print and colour. In the last few years, we have grown a schedule of workshops and sessions regularly sell out. Based on the reception we have received, I know that I am not alone in my desire to bring joy, craft and colour into our homes, and I feel consistently inspired to keep at it and to share the love.

I see pattern and colour everywhere, and this visual inspiration is what forms the basis of my designs. I want to take you on a modern block printer's journey – and encourage and guide you to take your own.

CREATIVITY AND CONNECTION

I am often asked about my business and my design process. My work tends to spring from three main areas of inspiration. The fabulous colours and 'thud-thud' sound of the block in Jaipur, the palettes and shapes I find in nature, and the decorative style of Vanessa Bell (a key member of the Bloomsbury Group) in her home at Charleston Farmhouse. All of these influences help to shape my creative process.

Many of us leave crafts behind at an early age, but I think creativity is an integral part of being human. Wherever I go in the world, I always seem to be able to strike up a conversation about decoration, pattern or the meaning of colour. It's a universal language that connects us all. And I firmly believe that we are all creative. For instance, we all make some kind of decorative decisions about our homes, often without even thinking about it, and it's important to nurture this connection to our inner creativity. Just as we need to make time to exercise, we also need to make time to be creative – it feeds and nourishes the soul.

I find working with colour particularly rejuvenating – it's an instant source of joy for me. One of my favourite elements of my job is choosing and printing with new colours – I get very excited about it! Putting different combinations of colours together makes me feel happy and some just make my heart sing. My reaction to colour is very instinctive and I allow this instinct to shape my design decisions. I hope that once you've read this book you will make this type of choice about the colours you print with, and find a shade that makes you experience colour happiness.

In this book I celebrate some of my favourite colours to work with, my three wonderful inspirations, and the people that have committed to follow their hearts in all that they do. I hope that it makes you feel as excited about block print as I do. As a craft it can be sentimental, nostalgic and imperfect, but at any rate it's full of love and passion. A block-printed piece will forever carry the imprint of the hands that created it – that is its legacy.

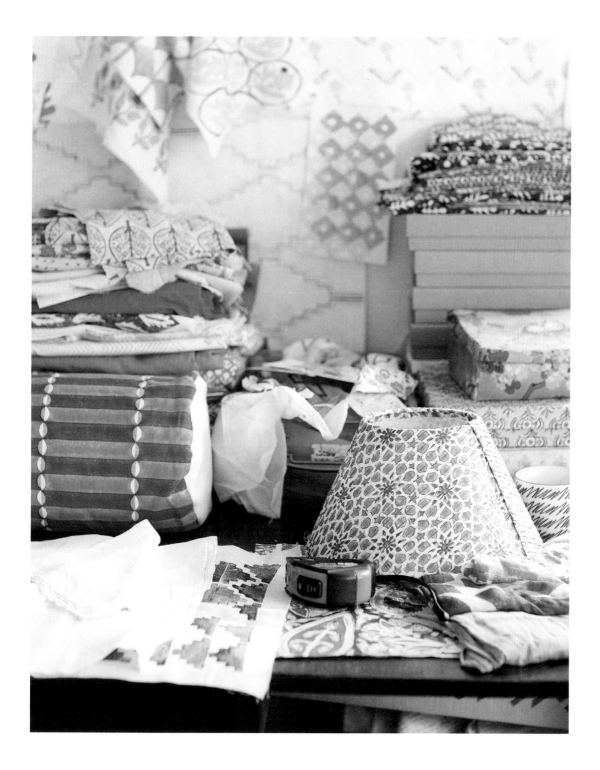

CAN I BE CREATIVE?

Loud tannoy announcement:

'We are all born creative!'

Before we learn to read and write (or use a screen), we have generally been handed paper and crayons. Play tends to be creative, using imagination to absorb the surrounding world as we find our way with our hands and our feet.

When it comes to arts and crafts, we progress from drawing a house, a tree and a stick person or two, to potato printing and painting in the early years of school. And then for so many of us, it stops. Creative crafts are put aside, marginalized and forgotten with a shrug of the shoulders or a 'Well, I wasn't very artistic anyway.' But imagine life without the work of our great artists. Imagine galleries without paintings. Imagine houses without wallpapers or pictures on the walls. Imagine no fabric for our sofas and chairs!

Thankfully, some people have found it in themselves to forge ahead with creative careers, but the arts and crafts world is fast diminishing. I feel (especially with three children under my wing) that it's imperative that we all get paint in our hair, crowd around our kitchen tables and declare: I CAN BE CREATIVE!

Because you can. Remember, I'm self-taught, and I want to help you reawaken your inner artist, too.

HOW I FOUND BLOCK PRINT

As I explained earlier, I originally stumbled upon block print in my twenties. Having been persuaded away from art at school, but knowing deep down that creativity was important to me, I wove my way through various weekend and evening classes (from book illustration and pottery to life drawing and beyond) until I found PRINT. And I haven't looked back. I realized that when you are ignited by a huge spark of passion for something, you will pursue it and educate yourself in it, and never let it go.

My determination and joy for this medium has since resulted in several fabric and wallpaper collections, and now a growing range of (I hope) joyful homeware. What started at my kitchen table as a passion project is now not only providing my family with an income, but inspiring global interest as it captures the imagination of like-minded people interested in design and, importantly, who are looking to make their house a 'home'. People like myself, who believe that the items in our homes should be well made, thoughtfully designed and full of cheer.

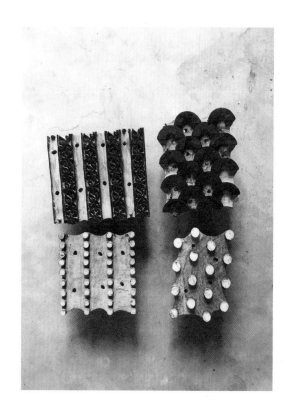

BEAUTIFUL BEGINNINGS

Block printing is one of the oldest known methods of transferring designs onto cloth. Records show that block printing may have originated in China around 4,500 years ago – and we still aren't bored with it!

But it was in India where people really experimented with vegetable dyes and patterns, and where they took the delights of block printing to new heights. Specific patterns and colours became synonymous with different areas of the country, while the intricacies of the design and the preciousness of the cloth reflected wealth and family heritage. In essence, the printed piece told the story of the wearer.

There is a deep-rooted history of printing in Bagru, a small village in Rajasthan. Across the area, *chippas*, a community of printers whose knowledge of their craft has been handed down from generation to generation, are still printing fabric like their forefathers. On pages 50–58 I explore the methods of the master printers I have discovered as we walk through their wonderful process.

Block printing has also been integral to the work of several British female artists like Peggy Angus, Phyllis Barron and Dorothy Larcher, and Enid Marx to name a few, and I hope that the potted history opposite will offer you a few thought-provoking insights into their work and design ethos.

I love that my craft has such a rich history, it truly has passed the test of time, and a great deal of my enjoyment comes from giving this ancient craft a contemporary slant for today's homes.

Peggy Angus (1904–1993)

Peggy lived in Furlongs, a farmhouse in the South Downs (just down the road from me), and was friends with other extraordinary artists like Eric Ravilious and Edward Bawden. Her home was her creative hub, full of brightly painted furniture and decorative, hand-printed wallpapers. Hailed by some as 'design's forgotten warrior', Peggy was firmly convinced that all of us are artists, and felt that we each had a responsibility to explore our creative side.

Phyllis Barron (1890–1964) & Dorothy Larcher (1882–1952)

Barron and Larcher were vanguards of the revival of hand block printing in Britain during the 1920s and 1930s. As well as carving their own blocks, they would print with whatever they could find – from combs to a piece of wood with string wrapped around it. They saw the entire process through from start to finish, and experimented with natural dyes. They ran a successful business and their fabrics can still be found on the market today – I am lucky enough to own a few pieces myself.

Enid Marx (1902–1998)

Britain's 'queen of patterns'. Enid worked for Barron and Larcher, who taught her how to block print and mix dyes. She later started her own business, and from her studio she designed and printed textiles that often featured her distinctive abstract or geometric patterns. Enid was particularly noted for her engaging and beautiful repeat-pattern designs for book covers and fabrics – she famously created some of the iconic designs for the moquette (the tough woollen fabric) that covers the seats of London Underground trains.

Angel Hughes 21st-century hero

Angel taught me the basics of block printing and enabled me to 'go it alone'. Having inherited a huge number of blocks from Yateley Industries (a charity founded by orthopaedic nurse Jessie Brown to give disabled girls a creative outlet by combining care with the art of block printing), she set up a studio in an unused barn on a Sussex farm. Here she experiments with various dyes, mordants and base clothes, resulting in a wonderful collection of linens and cottons that she transforms into items for the home. Her investment in and dedication to the craft, and her ready acceptance that things sometimes go wrong, has been a huge inspiration to me. I always try to bring these qualities into my own studio.

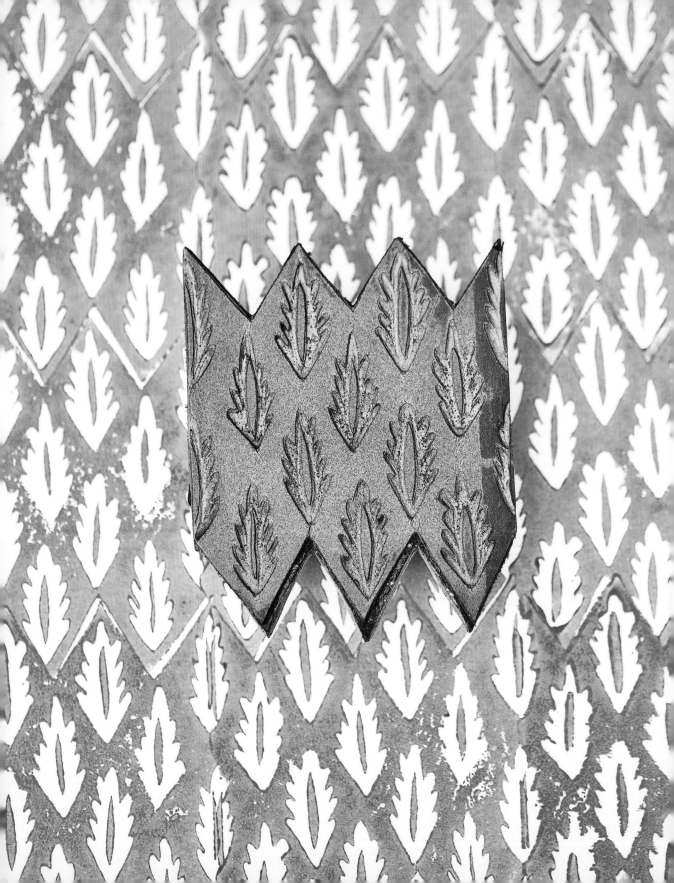

PERFECT IMPERFECTIONS

A hand-block-printed fabric stands out from the crowd. Its beauty lies in the mark of the hand that printed the cloth. In some cases this is the same hand that also carved the block in wood or lino. One of the many things I love about the printing process is that you can be in control of the design from start to finish – you are the master of many skills.

You can adapt and evolve during every stage, from carving the block to finalizing the design. You can make decisions as you work with relative ease, and the choices you make along the way (your colour selection, pattern conception and chosen medium), culminate in the creation of a very personal connection with the finished piece. I suspect it's this quality that makes the process so interesting and keeps the craft alive – in every sense of the word.

All my designs start as simple pencil drawings and I have filled book upon book with sketches and doodles. Some drawings speak to me more than others, and it is these ideas that end up being carved into

lino or wood blocks to form the printing 'tool'. From the very first time I tried block printing, to my most recent work in my own studio, the most excitement comes from lifting the block and seeing the print I have created. This thrill led to the creation of my business and fuels my desire to share the joy of this craft.

The perfect imperfections created during the printing process make it a real and lively craft, and steep the fabric or paper in charm and interest. The odd movement between each placed block is what gives a piece energy and life – something that simply cannot be achieved by the 'exactness' of machine printing. It's an authentic process, characterized by honesty and passion, and this is what makes it beautiful: its perfect imperfections.

HOW TO USE THIS BOOK

This book is for:

- People who want to find their inner creativity.
- People that love block print.
- People that want to translate their own designs onto fabric and paper.
- People that want to be inspired by the amazing ability we all have to create.
- People that love colour and pattern.
- People that want to decorate their home and stamp their own mark on it.
- People who have enjoyed my fabrics and wallpapers and want to know more about my business.

So how does it work? I wanted this book to be inspirational as well as informative, and as I find images speak louder than words, I have included as many as possible in the hope that they will spark your imagination too. With that in mind, you don't need to read from start to finish, but can dip in and out wherever your creative impulse (or latest idea!) takes you.

If, on the other hand, you're all in, it's useful to know that the book is divided into two parts. The first explores my biggest inspirations: India, nature and the Bloomsbury Group's approach to decorating. Focusing on my personal relationship with each and the ways in which they have influenced me, I explain how these sources of inspiration have helped me to develop ideas, kick-start my inner creativity and create my own block prints.

The second part shows you how you can do the same, because this book is not just for people who are interested in block printing, but for anyone who likes *making things*. The wonder of block print is that it can be applied to pieces for the home or items that make wonderful gifts for friends and family. People of any age can enjoy the process, and here you'll find all the practical advice you need to get started, plus some lovely project ideas (all of which can be made at the kitchen table).

Ultimately, it was important that this book should feel as if you are joining me on my design journeys. It is a very personal account of my learnings and experiences. I hope it inspires you to give block printing a go, and to open your eyes to the joy of colour and pattern that surrounds us and offers itself to us on a daily basis.

DESIGN JOURNEYS

When I'm designing, the creative process feels like a journey. It begins with an initial spark of inspiration and eventually (after much experimentation), ends at the final, finished print. I want to show you the places and people that ignite my imagination, awaken my inner creativity and start my personal design journeys.

Whether it's a trip to the printers in Jaipur, a stroll in the forest, or musing on the works of printers and decorators past, we will explore what I see, how it influences my designs, and which colours have the strongest appeal to me. We will look to the Bloomsbury Group for their clever use of simple pattern, their captivating colour palette and their fearless decorating style. We'll turn to the natural world for its fascinating shapes and the enchanting chaos of its patterns – not to mention the rich spectrum of earthy tones on offer. But first, let's consider the bold colour combinations found in India, together with their celebration of florals and repeat patterns. It's a very good place to start…

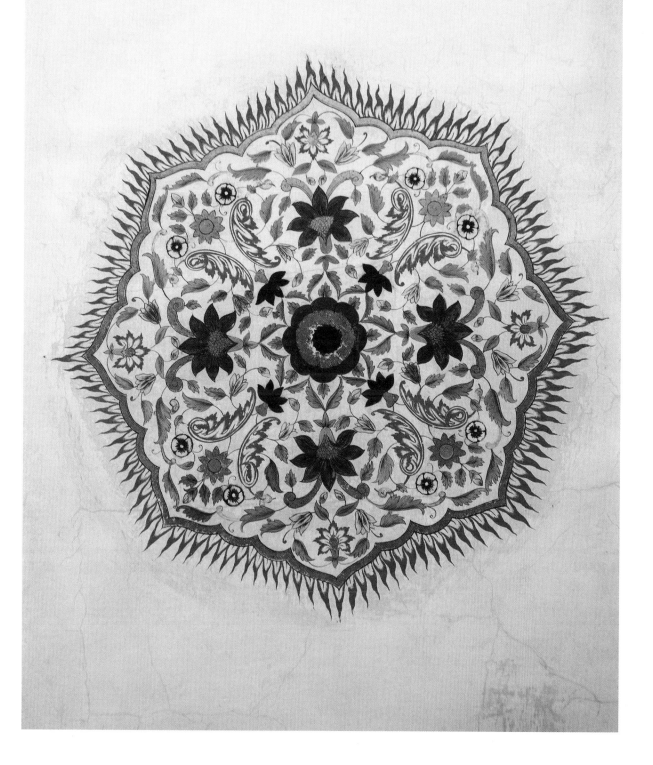

INSPIRED BY... INDIA

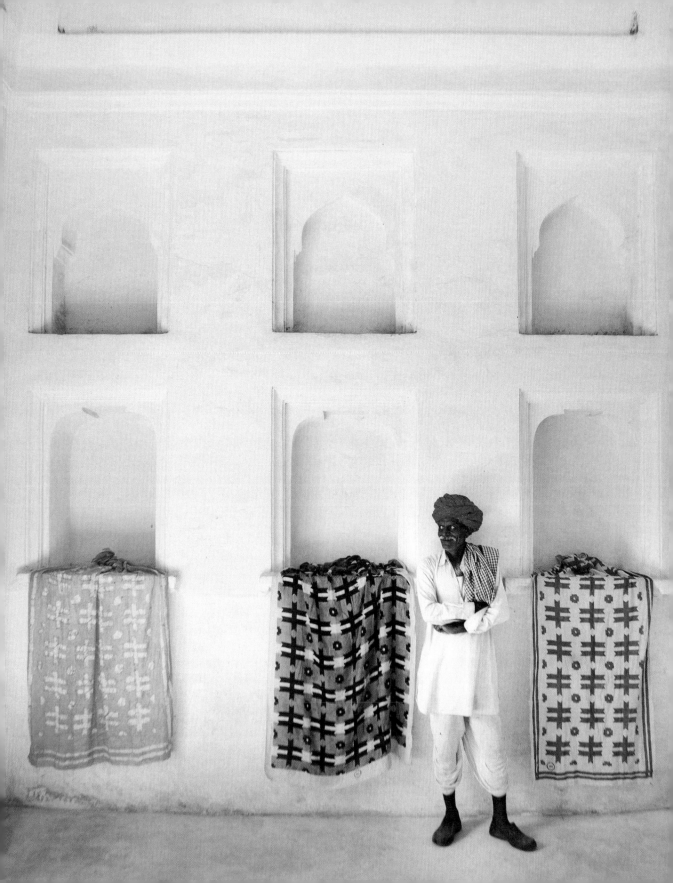

From the moment I stepped out into the fast-paced city of Delhi (the first stop on my trip), I was mesmerized. It was hot and steamy, it was noisy, it was bustling, it was an array of colour and it was alive! I was enthralled, and my heart beat with the same excitement you feel when you first meet someone you like. It was the start of a new romance for me. I was in love.

Few places embrace colour and embellishment in the same all-encompassing way as India. In a country so vast and so varied, this love for decoration is a powerful prevailing energy. Everywhere you look – from the way people dress, the complex architecture, the bridges, the lorries, the walls and even the elephants! – offers a celebration of pattern and colour. It's like no other place on Earth. The bold, no-holds-barred use of colour here is incredibly heartfelt, and has a hugely uplifting and positive effect on me. I now work with printers in Rajasthan (a state in northern India renowned for its traditional craft industries), in particular the city of Jaipur and nearby villages Bagru and Sanganer.

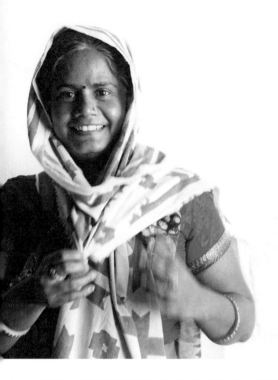

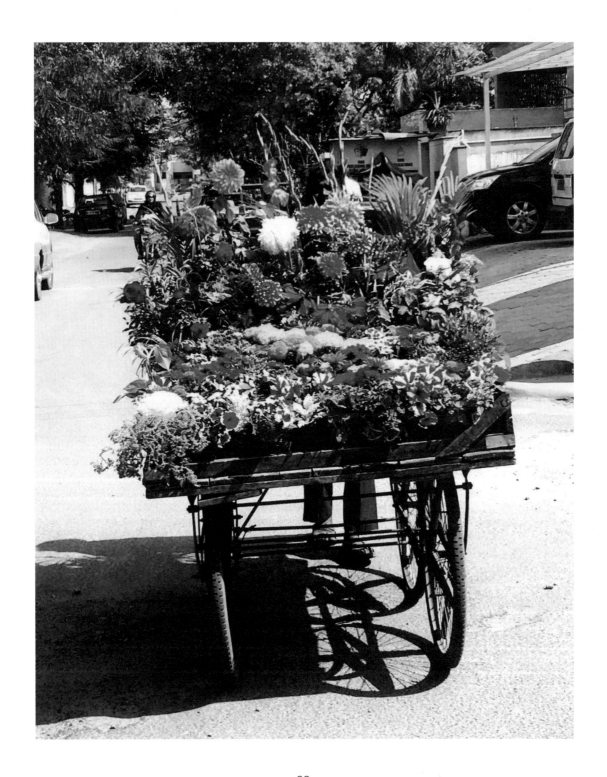

FLOWERS OF INDIA

I love nothing more than rising early and catching a tuk-tuk (the tourist's term for an auto rickshaw) to Phool Mandi, the main flower market within Jaipur's walled Old City. The scent of roses permeates the crisp morning air, enormous cotton sacks swaddle countless marigolds, and traders carry bloom-filled baskets above their heads as they make their way through the crowd. It's a flower fantasy. The energy here is effervescent and watching the locals buying, selling, laughing and catching up, fills me with joy. This is where I meander with my camera, stand and sip from a paper cup of steaming chai, and soak up the exuberance of the atmosphere. It must be one of the most pleasing places in the world to behold.

While I find a fresh vase of flowers at home in the UK a real treat (and more often than not, a sign of a special occasion), flowers are part of everyday life in India. The sides of vehicles are emblazoned with them, vases, urns and gardens are filled to bursting, and carts are piled high outside temples. Huge stone bowls of flowerheads greet you at most building entrances. Weddings are festooned with thousands of flowers, and flower garlands are a significant part of almost every official event.

Flowers, and the natural world, have a special spiritual significance in India. For example, Hinduism, one of the most widely followed religions in India, holds that people and nature are intrinsically linked, and that the former is equally as important as the latter, because humans rely on the natural world in order to survive. Similarly, with such a brief respite from the searing temperatures, people celebrate the period when the green landscape shows itself after the monsoon. Perhaps by incorporating elements of nature within their designs – in their paintings, prints, colours and motifs – they remind themselves through the hot, dry summers that 'life' will come again.

Flowers must surely be one of the most successful and time-tested pattern motifs. One of my most successful fabric designs features a marigold. The strong orange and yellow is so bold and zingy, and feels symbolic of the hot sun in Jaipur. Another prolific flower is the rose, which has an incredibly romantic history here. Arriving in cartloads with the Mughals, the flower was transformed into fabulous perfumes, and used to decorate palaces. I too have added my own rose design to my fabric collection.

LIFE IN COLOUR

Among the huge diversity of cultures, customs and languages that exist across the vast expanse of India, one constant seems to be the importance of colour. Its symbolism, its historical significance and the stories it can tell, instil it with the vital power to connect.

If ever there was a place to go and immerse yourself in the energy of colour, it's Jaipur. It's even known as the Pink City. Rich, bold colours are ubiquitous and offer an instant blast of inspiration. You cannot fail to notice and be drawn to the colours worn here, and the decoration of the surroundings: people dress in vivid hues, buildings are painted in rainbow shades, bridges are brightly embellished with lines, patterns and floral motifs, temples are full of vibrant flowers, and even lorries are adorned with brilliant, intricate designs. The bold cacophony of colour of everyday Indian life is a sight to behold – a moving palette of delight that offers a welcome sense of freedom.

And then there is Holi, the Festival of Colours – can it get any better? Handfuls of powdered paint flying through the air, covering the ground, people and animals, to celebrate the coming of spring. The colours each have their special significance including red for love, green for spring and yellow for turmeric.

My travels to India have given me the courage to be brave with colour, and have taught me the importance of surrounding yourself with the colours that make you feel happy. I find colour uplifting, and now need it around me at all times. One of my favourite things to do in Jaipur is to stand at the print table and watch my new designs emerging in the chosen colourway. (I sometimes even wonder if the blocks are just my passage to working with colour – a mere tool to get it onto the canvas!)

I find the possibility and scope of the palette in India is much broader than the colour conventions accepted in the UK. You can wear whatever you like colour-wise, in fact, wearing hot pink in India is akin to wearing camouflage in the English countryside. The people here are fearless when it comes to colour, and this confidence is something I admire and embrace. I have found it empowering to bring it home with me, and always try to incorporate it in my work.

Here are some of the colours that have inspired me in India.

INDIGO

Rich and delicate all at the same time, indigo is probably one of the most iconic colours associated with India, and the dye has been used here for thousands of years. In essence, it is a shade resulting from the fermentation of *Indigofera* leaves. The colour doesn't actually exist in nature – in liquid form the dye is more of a yellow-green. The signature shade develops when the fabric is removed from the vat (the dyeing bath) and comes into contact with oxygen. This is when the colour magic happens as the fabric takes on a powerful, inky blue hue. That being said, the variation of shade is fairly wide, and the final result will depend on how much time the fabric has spent in the vat, and how many times it was plunged into the dye during the process – another good example of perfection obtained through imperfection!

Indigo is particularly important in Bagru, a small village south-west of Jaipur, where I work. The ground-level vats, each around 12m (40ft) deep, are too enticing not to explore. They inspired me to design a range of scarves and fabrics that are printed using a mud-resist printing technique called *dabu*. Fabric is block printed using a local mud paste (the secret of which is fiercely guarded!), which stops the dye permeating the cloth. The printed fabric is then plunged deep into the indigo vats. The negative areas of the design (see page 122) achieve a lovely light shade of blue after only a few plunges, and a richer, deeper tone when left in the dye for longer periods of time.

DESIGN NOTES

Despite its seemingly inescapable presence (the colour of the sky, the sea, our planet!), blue is actually very rare in nature. But it's the world's favourite colour, and in terms of design I find it to be very easy on the eye. For me, blue is neither masculine nor feminine, and sits well with most other colours. Try putting something turmeric-coloured against it – so fabulous. Shades of blue are almost guaranteed to work when printing, and are generally a safe yet bold colour palette to begin working with.

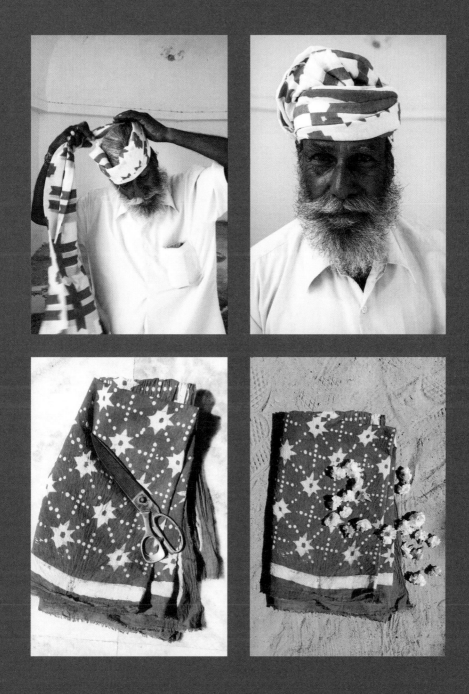

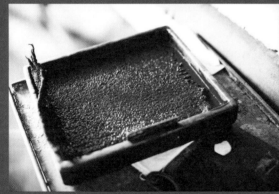

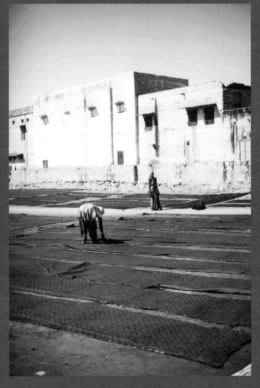

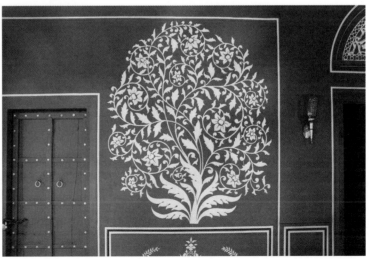

TURMERIC

One colour that resonates across India is yellow. It is symbolic of hope, energy, joy and happiness. Buildings are painted in a multitude of hues (dandelion, canary, lemon, amber…), ladies wear bright yellow saris, and chai wallahs watch as vats of their golden-tinted chai bubble away ready for the next customer. The original source of all these shades is turmeric.

The turmeric plant (*Curcuma longa*) is part of the ginger family. We now recognize turmeric root for the healing strength of its properties and anti-inflammatory qualities – I start every morning with hot water, coconut oil and a slice of turmeric, which stains my fingers as though I have been in the studio mixing paint! Its initial popularity can probably be attributed to the amazing health benefits it has to offer, and that in turn might explain why it became such a fundamental colour for auspicious occasions and wedding celebrations.

One of my favourite, and lasting, memories from Jaipur is its incredible marigold fields. Marigold flowers open wide when the sun is out, and the multiple layers of petals create a beautiful full bloom of colour. To many they represent passion and creativity. On an early morning walk through the wholesale market, you'll see bundles and bundles of marigolds heading to temples and offering sites. It is the most uplifting vision, and I bring pops of yellow into my designs wherever I can.

DESIGN NOTES

Yellow sits well with everything. The colour is bold and bright and creates a cosy and inviting feeling in the winter. It also absorbs the rays of the sun to help keep you cool in summer, which is yet another reason to wear or paint the walls yellow, as well as, surely, the instant injection of joy it brings. I have it in my kitchen and it's so cheering, especially on a damp, grey day in the forest. I use it on lampshades to achieve a warm glow and have also wallpapered my youngest's room with our Fern wallpaper in mustard, which is now one of my favourite spaces in the house. For me it is like bringing the sunshine in.

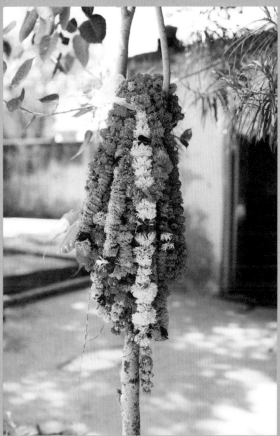

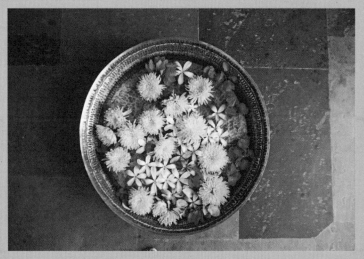

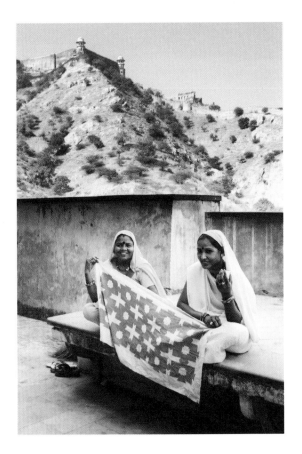

MADDER

The Indian madder plant (*Rubia cordifolia*) comes from the coffee family. The roots are boiled to leach out the colour, and the fabric or threads are plunged into the water once cold. Sometimes madder is added directly to the print paste and then transferred onto the fabric with the block. Madder root is used to create a wide spectrum of red tones – from rich reds to coral oranges to blush pinks.

Dyeing with madder feels a little bit like colour alchemy – so many colours can be created with it. There is something particularly delicious about pink madder shades. These natural pinks are created when alum is added to the root in the dyebath until the desired shade is achieved.

In Rajasthan, shades of madder pink can be found everywhere – they flood the flower markets, fill the vats that dye the cloth, and give the architecture its distinctive character. One of my favourite sights are the traditional candy-pink turbans worn by the older generations. The vivid shade is beguiling and energetic – it's wonderful to see.

The buildings of Jaipur's Old City have been a romantic dusty-pink colour since 1876, when Prince Albert visited and the whole city was painted pink to welcome him. Jaipur has been known as the 'Pink City' ever since, and its buildings are freshened up with the same rosy shade to this day.

DESIGN NOTES

Pinks are very friendly shades to bring into your home, and I love the rustic tones that sit beautifully on a natural-coloured cloth, or that pop when printed onto bleached linen.
I find pink really reassuring and warm, especially through the colder months.

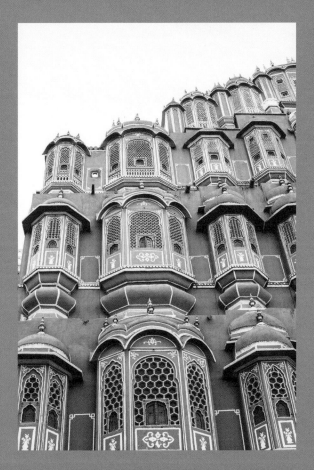
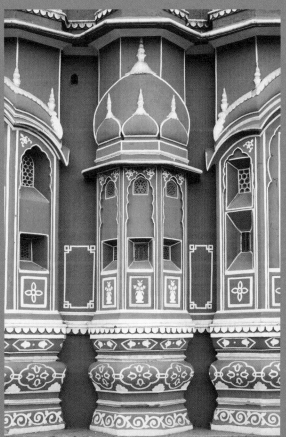

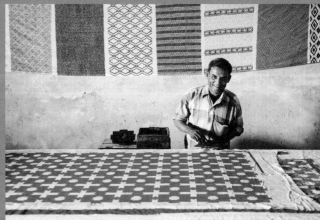

RICH TRADITIONS

What I really love about Jaipur is the transparency of its economy. When you walk the streets, you can see the lifeblood of the area – block carvers, block printers, fabric washers, potters, miniature artists, papermakers, weavers, jewellery makers… Artisans line the streets of the city. There is a vibrant energy in this open, shared working environment, where everyone pulls together and supports one another.

After agriculture, craft is the city's second largest employer, and Jaipur actively supports its creative industries. Craft is seen as both inherent to its cultural history and a distinctive tourist attraction that draws an endless flow of visitors to the area. Various organizations have recognized the economic importance and potential of this great tradition, and are striving to improve working conditions, support direct selling (with activities such as heritage craft walks), and encourage contemporary design alongside the time-honoured items we know and love. This is great news, but as is the case for any modern handicraft industry, there is a constant pressure to mechanize processes, as the allure of machine manufacturing threatens to tempt producers away from craftwork.

While block printing is just one of Jaipur's rich crafting traditions, its longevity, resilience and continued popularity, surely suggest that it's a vital sign of the city, perhaps even integral to its well-being. In her books about India, Fiona Caulfield has noted that there it is normal to make everyday and decorative items by hand, whereas in the West this is seen as an indulgence. This really resonates with me, and I think it's important for us to see handicrafts as 'normal' and essential to our well-being too. It has spurred me on to open up more printing workshops, so that we can also connect to traditional skills and benefit from the positive effects of crafting together.

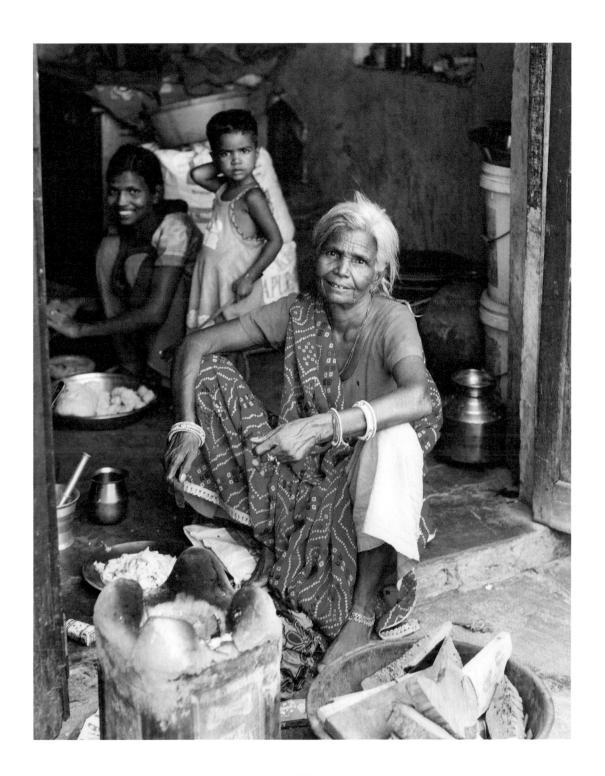

THE BLOCK

Blocks can be carved into a multitude of woods, although the options are usually governed by the intricacy of the desired design. Blocks made from hardwood are, of course, stronger than those made from softwood, and have a longer lifespan. I have been told that a hardwood block has a working life equivalent to a printed length of 400m (1,300ft). Many of the blocks on sale in the markets here are chipped and worn out. While they are no longer viable printer's tools, they are exceedingly decorative, inspirational objects in themselves.

The wood most commonly used in the area that I visit is *sheesham*, otherwise known as North Indian rosewood. An individual block is needed for each colour to be printed. Some early chintzes imported into the UK in the 17th century would have required up to 12 individual blocks, printed over the top of one another, to achieve the finished print.

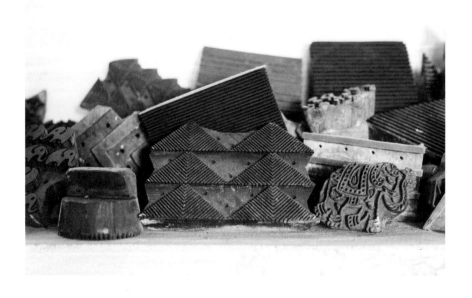

CARVING THE BLOCK

First, the slab of wood is planed flat. It is then covered in a white paste (a mixture of quicklime and PVA), so the carver can see their markings. The design is then drawn over this in pencil. Using a mix of tools, including chisels and drills, the design is carved out of the block. The remaining raised area will create the printed design, technically known as the 'positive'. The space that is carved away is referred to as the 'negative'.

Once the block is carved, the sides are trimmed away so the printer is able to see right up to the edge of the design as they print. The carvers also drill holes through the negative areas of the design to allow the wood to breathe, and to give the block longevity. A handle is attached to the back, and the block is left to soak in mustard oil for a few days. The oil strengthens the wood and protects it from cracking, ultimately giving the block a longer lifespan. Once the soaking time has passed, the block is left to dry and soon it's ready for printing.

The sound of the blocks being carved is rhythmical and atmospheric. It's completely mesmerizing to watch a slab of wood become such a beautiful tool. I find it quite emotional – it's such a pleasing process.

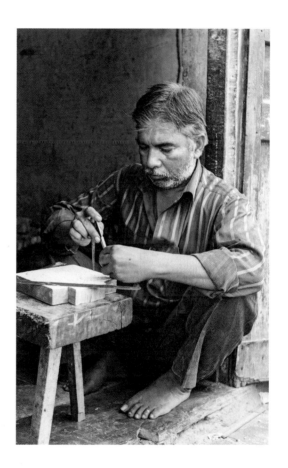

COLOUR MIXING

Each printing set-up employs a dye master, this is the person who looks at the desired colour and works their magic mixing skills to produce as perfect a match as possible. They are highly skilled and can miraculously create any shade of the rainbow with the sage addition of a little of this colour, and a little of that colour. It's rare that they keep 'recipes' or measure the different colours out, the task is mainly performed by eye.

Colour pigments come in many forms and need to be mixed with a substance known as a 'binder' to create a print-ready paste. They are then combined with a substance known as a 'mordant', which adheres the colour to the cloth. The resulting dye is poured into trays that are placed onto tall trolleys – this allows the printers to move with ease as they work along the print table…

In a dream world we would only use natural colours, but they can be very volatile and are likely to fade. The use of chemical- or kerosene-based colours has had a detrimental effect on the health of the printers, and on the drainage system in the printing areas. Luckily there are now more companies working towards more ethical colour pastes and pigments. I will always make sure my printing is done with AZO-free dyes while in India.

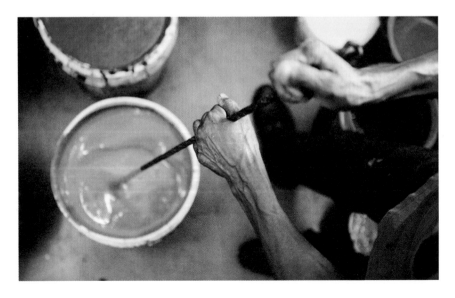

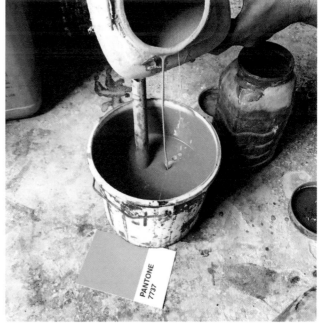

PRINTING

Print tables are the large, sturdy tables where the fabric is laid out ready for printing. Some printers have factory set-ups with rows and rows of tables – some under corrugated shelters, some at the top of buildings, many are found at the back of the printer's house.

Most tables are about 5m (16½ft) in length, but there are some that stretch up to 10–12m (33–39ft) long. The tables have to be very strong, and wide enough for the fabric to lie flat. (Originally, the tables were created to perfectly fit a length of sari and the blouse that goes with it, so that they could all be printed in one go.) To prepare the tables for printing, they are covered with layers of cloth pinned tightly in place – usually hessian is secured at the base to create the 'padding' and then a finer layer of calico or muslin is laid over the top. The padding acts as a sort of 'shock absorber' for the printing block (see page 118).

Once washed and ironed, the printing fabric is pinned carefully onto the prepared table. Some fabrics lie better than others, and the finer ones can move about during the printing process. A virtually invisible thread is pinned in place as a guide to ensure the printed fabric will have a straight edge, and that the right angle in the corner is as straight as possible. As the printers work purely by eye, the thread is essential.

And so the printing begins. The background block (the *gadh*) is printed first, followed by the outline block (known as the *rekh*), and then a more intricate fill-in block might be applied (the *datta*). Fabrics can be printed with as many as 12 different blocks, each adding a new colour to the pattern. The joy of my designs (for the printers anyway) is that they include only one or two colours, which means the printing process can be completed quickly. When I started out this was quite perplexing to some of the printers. To them it felt unfinished, but I really like the simplicity of this contemporary twist, and think it works well for modern homes.

Different regions have adopted different styles of printing over the years. The village of Bagru, where I have some of my designs made, is particularly synonymous with delicate small flower prints known as *buti*.

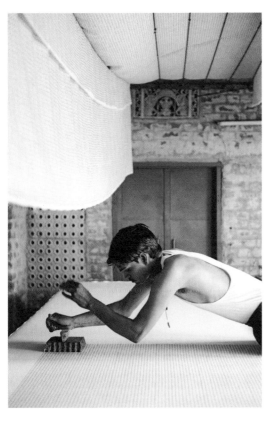

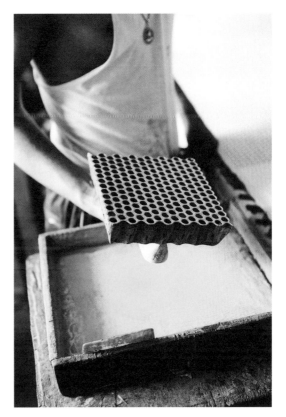

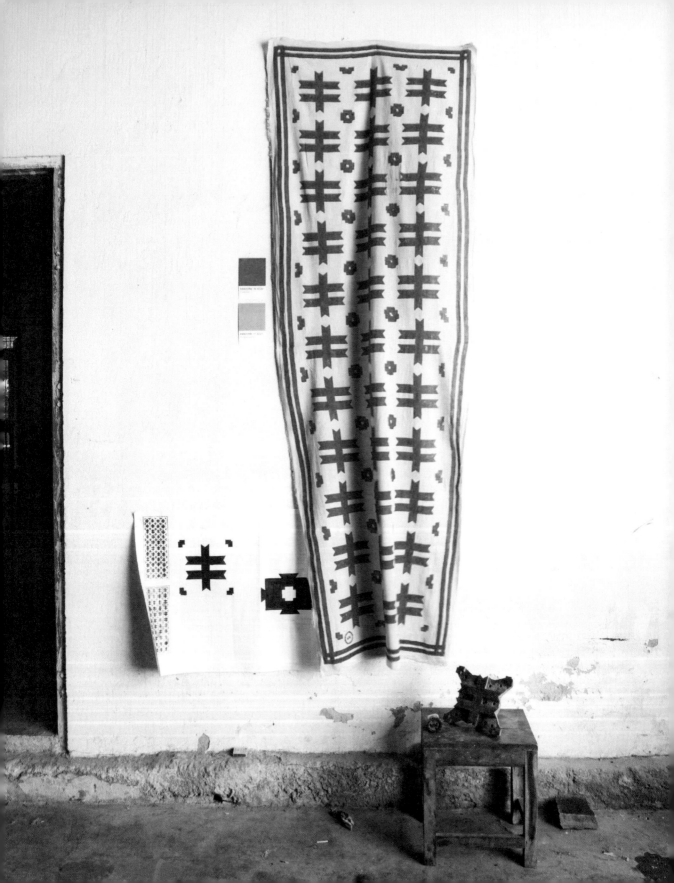

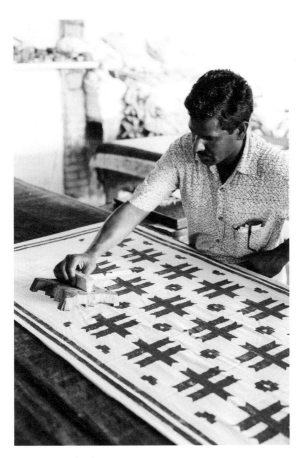
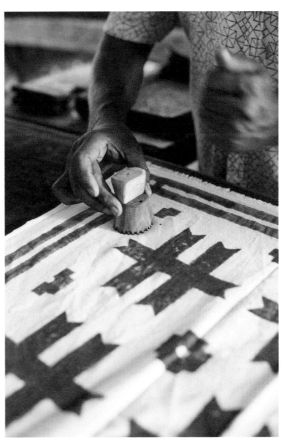

DRYING

When the complete pattern has been printed, the fabric is dried. The drying method depends upon the space available. The larger factories might have baking machines, otherwise the fabric is laid out in communal drying fields that create an ever-changing patchwork of colour.

Alternatively, fabric is hung from very tall bamboo frames. In Sanganer (a bustling town in Jaipur's suburbs, renowned for its craft enterprises), you see these structures lining the roads. The wonderful tapestry of colourful fabrics wafting in the breeze creates the most incredible sight.

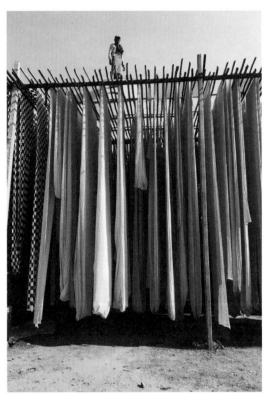

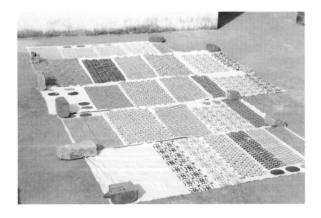

FORGOTTEN BEAUTY

Despite efforts to support traditional crafts (particularly through the growing interest in craft tourism), the block printing industry is in real danger, as machine-printed fabric (produced at a much cheaper rate) pushes it aside. I feel unspeakably sad at the prospect that this hive of activity could come to an end. In the creative hubs where I take my designs to be printed, block print plays a huge role in the life of the area. Not only does it create employment for hundreds of people, it's a craft that connects the community, keeps the inimitable quality of handwork (the 'touch of the human hand') at the heart of production, and inspires designers like me to collaborate with incredibly skilled artisans.

I believe that we need to keep this art form alive by sharing our love for its beauty, and by showing each other, and our children, that there is artistic and financial merit in keeping it going. The beauty of a piece of block-printed cloth must not be overlooked. When its story is told, and you realize the number of skilled hands it has passed through, it really is leaps and bounds ahead of any other means of production.

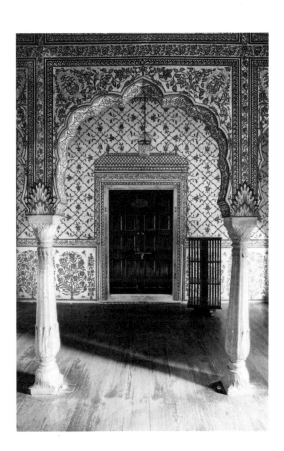

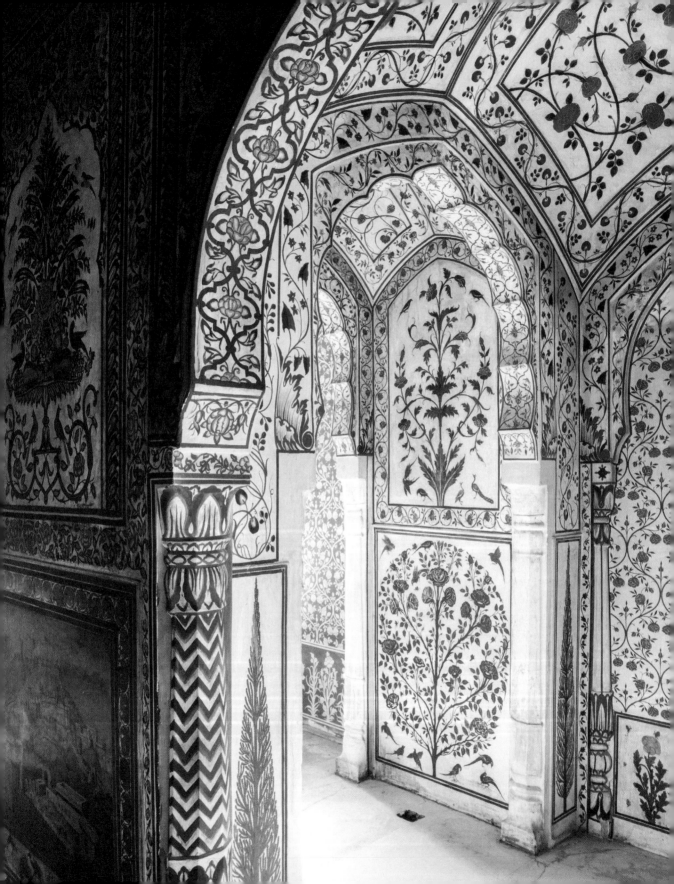

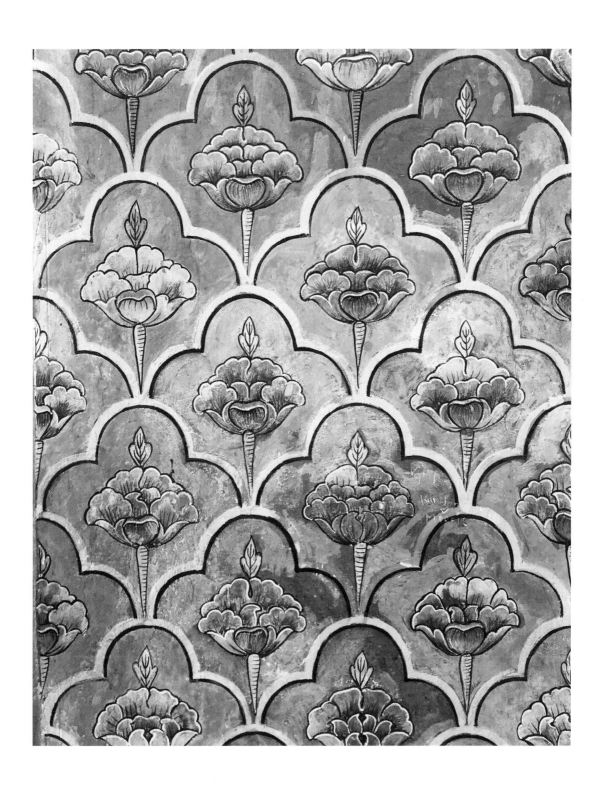

HOMECOMING

When I visited India for the first time, I had expected it to be a one-off trip. I never expected to start working with the artisans here, and I certainly never imagined I would be returning once or twice a year. My life and my work feel intertwined with Jaipur, both in a commercial and creative sense – its energy has got under my skin and into my designs. It's opened new doors of inspiration and filled my mind with countless thoughts and ideas. And just as I feel quite 'at home' when I'm there now, I have also brought Jaipur back home with me. I feel much less inhibited, not only in how I dress, but in how I decorate my house. My trips have been a creative awakening for me. I am much more confident in my use of colour at home and in my work. Our latest Jaipur fabric collection has been so well received, it seems that many of us need this colour injection to brighten our days.

I am now inextricably bound to Jaipur. I am strengthened by the relationships with the people I work with there, the familiarity I feel each time I return, and the endless learning, learning, learning from another culture – the different mindsets it has to offer and the possibilities presented by another way of life. All of these things are bound up in my work as a block printer.

INSPIRED BY...
NATURE

Oak trees have always seemed to mark extremely important moments in my life – I climbed them in my parents' garden as a child, was married underneath one as an adult, and now three enormous oak trees watch over our cottage. Oaks have played an important role for many throughout English history, in which the tree is deeply embedded in folklore – symbolizing many qualities including strength and wisdom.

Significant occasions in life are often marked by symbols of nature, from animals and birds, to flowers and trees. We are inherently part of nature, and I think we like to use this type of symbolism to remind ourselves of this. I am certainly at my most peaceful when I am 'in' nature and it's probably where I find the strongest sense of clarity.

One of my best-selling wallpapers is a fern pattern. The idea for the design came from a fern that I collected on a walk with my children – a simple frond that I drew around to transfer it onto a block of lino. That frond became a clean, crisp and simple print, which now adorns many a wall in fantastical shades of yellow and blue. People connect with these shapes and feel comfort in bringing them into their homes.

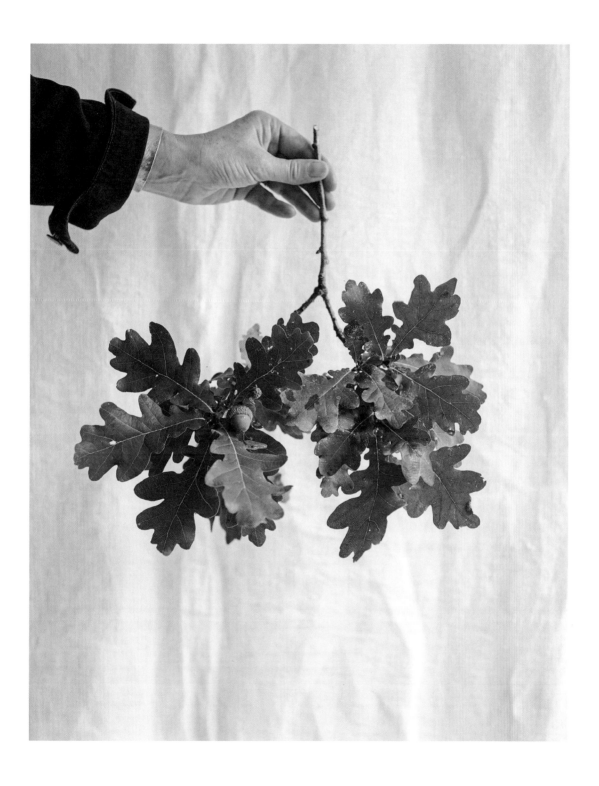

HOW I FIND MY COLOURS

Recently I became interested in the origination of colour, so I attended a workshop where we made watercolour paints using pigments collected from their source (be it plant, mineral or rock) mixed with gum arabic to create a natural palette. For instance, we used azurite to create soft, deep blue tones and Persian berries to create rich golden shades. The resulting paint colours were astounding and beautiful to work with.

I also spent a day at our local farm learning to create and work with natural dyes made from madder – from digging up the root, boiling it, and finally submerging some lovely wool into the dyebath. We explored the myriad of shades that can be achieved when the root is combined with other ingredients from nature's bounty (adding, amongst others, rhubarb leaves to create coral tones).

There is magic in these earthy tones drawn from the land, and in the array of colours that can be found on closer inspection out in the natural world: from tree barks of deep ochre, to the varying tones of green leaves, to the amazing first pops of pinks, blues and yellows that appear each spring from the damp soil, to the hazy pastels of summer and the deep, bold shades of autumn. Nature's palette is constantly evolving, inspiring and hopeful.

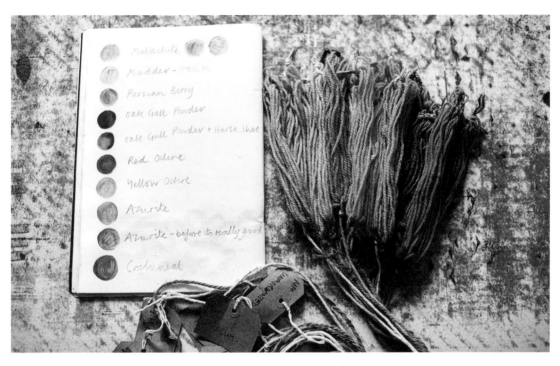

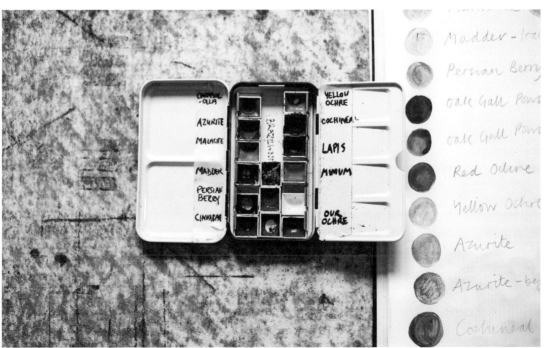

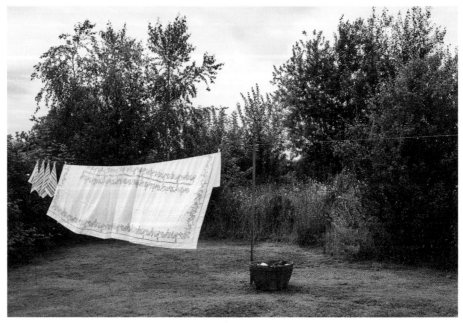

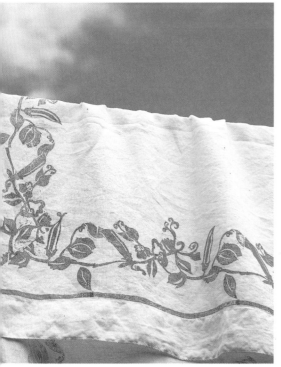

WALKING THROUGH PATTERN

I see my walks through the countryside as a perfect opportunity to be inspired. I used to walk all the time with the children when they were young – we would move slowly, stop to look at things close up, and collect items for our nature table. It was then that I discovered how wonderful our walks were for finding and creating repeat patterns. I realized I didn't need to draw an exact replica of the leaf or flower we had collected. Instead, I took the outline – the simple feeling of the shape – and re-imagined it to the point that it was still recognizable but teetered on the edge of becoming a geometric design.

We are often so busy, and our minds so full, that we don't even notice we are constantly surrounded by potential inspiration for patterns and prints. Try putting your phone away and taking a walk, be it in the city or in the countryside. If you start to look closely you will see lines, curves and shapes everywhere – in the silhouette of the skyline, the outline of a flower or fallen leaves on the ground. All of these can be drawn in their simplest form to become a print. You can also use pattern to interpret the sources of inspiration you encounter. I urge you to go outside with your notebook and look closely for the inspiration nature has to offer.

Here are some really simple patterns that we see in nature all the time, often without realizing.

CIRCLES
In a tree trunk, ripples in a lake.

SPOTS
On the wing of a butterfly or ladybird, raindrops, toadstools… I love a spot!

STARS
In the sky, star anise, and have you ever chopped an apple across the middle?

SPIRALS
Ferns, fossils and shells.

BRANCHING SHAPES
Trees and corals.

GEOMETRIC DESIGNS
Honeycomb, cobwebs and snowflakes.

WILD TEMPLATES
There are thousands of natural shapes that can be instantly translated into block print designs. Petals and leaves, particularly four-leaf clovers, are some of my favourite pattern-making tools.

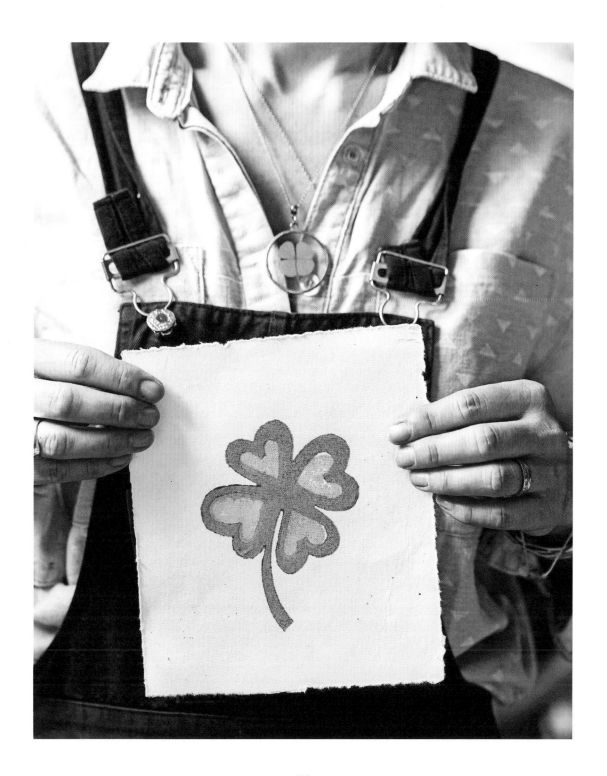

FINDING INSPIRATION

I find it very easy to find inspiration in nature. Quite simply, I love it. I walk in the forest to renew my spirits, to exercise, to take some downtime and to find enjoyment. The children feel free in nature and we all find the space that we need to re-establish a sense of equilibrium in our world of constant digital distractions. It feels very instinctive to draw on and be motivated by our surroundings in this way. Nature has always been one of the greatest muses for arts and crafts and provides a vast mood board – an infinite treasury of patterns, textures and colours.

It also provides endless scope for interpretation. In India, for instance, the calming continuity of flowing water is captured, re-imagined and symbolized with a simple, repeated chevron design. I'm very lucky to live within a forest and can pop out of my back door to pluck inspiration off the ground. Here for instance, I selected an oak leaf and drew around the outside – creating an interpretation of the shape. Using tracing paper, I played around with how I might repeat the design in a print. So you can see even the simplest piece of inspiration can lead to the creation of a striking pattern.

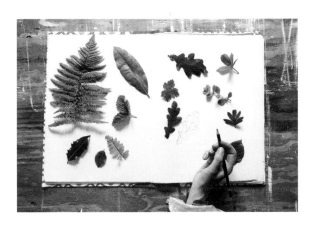

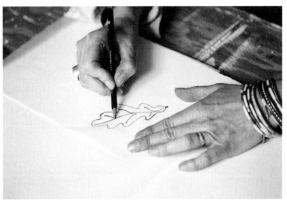

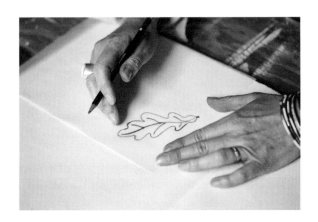

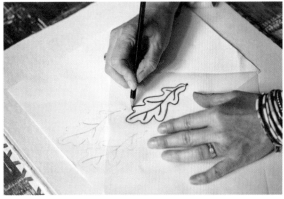

MINDFULNESS

One might ask why we celebrate nature and why it's so often reflected in design. I talked earlier about the symbolic significance of nature, and perhaps this explains its prolific role. But for me, it's because it's essential to our well-being.

It is when I am 'in' nature that I feel most like myself; where I literally feel 'down-to-earth'. Walking in nature clears my mind, brings down my heart rate, gives me space to think, to be, to reflect. I know this sounds intense, but it's increasingly important in this non-stop, round-the-clock world to be grateful for, and to understand, just how important nature is to our mental health. I think this is why I so often turn to the natural world as a source of inspiration. I am constantly amazed by its resilience when the first buds emerge and life flourishes once again at the start of the year. The seasons are a constant, they may play with us at times, but spring, summer, autumn and winter come around again and again to provide a quiet, reassuring rhythm to our lives.

And just as mindfulness can be found in nature, I also believe it can be found in the block print process. The rhythm of the block being placed and removed repeatedly draws in our concentration, as we carefully watch our design grow across the paper or fabric. When I am printing long meterage, I become completely absorbed. It's a meditative and demanding process, and while I feel physically tired when the pattern is complete, I also feel renewed and rejuvenated.

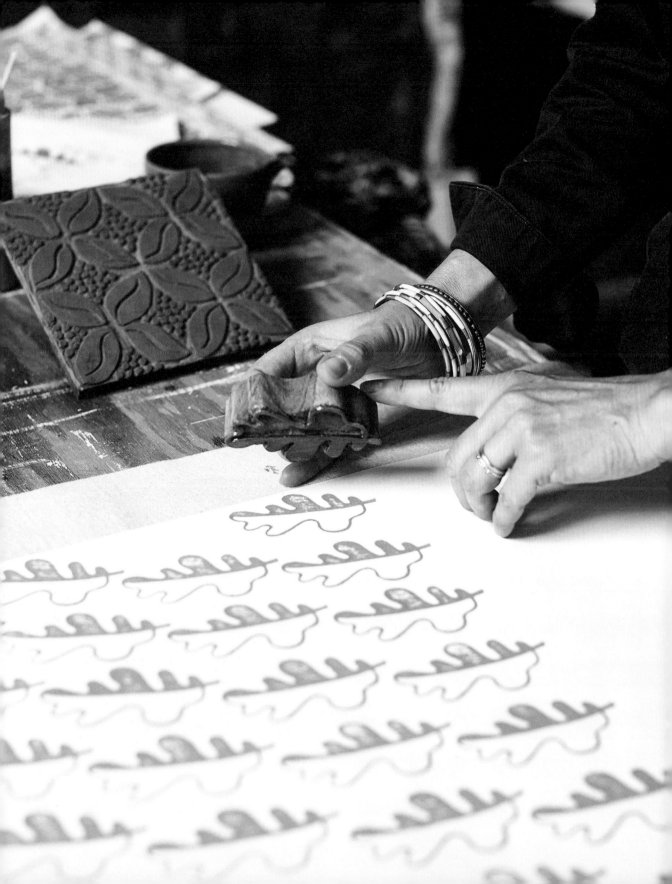

BACK TO NATURE

Many crafts are an extension of nature and simply wouldn't be possible without it – think about the clay needed for ceramics, the pigments required for paints, and the wood that is essential for sketchbooks and, of course, for creating printing blocks.

In my mind, there is a deep connection between block print and the natural world:

Designs are inspired by nature.
Blocks are carved from wood.
Cloth is woven from flax, cotton, or silk.
Dyes are made from natural pigments in plants, minerals and rocks.

…and it's this simplicity and elemental connection that keeps the process serene and timeless.

The idea that block printing is intertwined with nature was perhaps most famously explored by British designer William Morris. In 1881, Morris experimented with the craft and looked to nature as a source of inspiration, incorporating birds, berries, leaves and florals in his designs. (One wallpaper design featuring interweaving flowers and foliage required 68 separate printing blocks to complete the pattern!) He also used natural dyes in defiance of the growing supply of cheaper, synthetic ones. Morris recognized the need to make our homes places of beauty, and used patterns depicting the natural world to achieve this.

EVOLVING THE PROCESS

In nature, nothing is in perfect alignment. Instead there is a wonderful sense of organized chaos. Things exist in a constant state of change as we move through the seasons, and I love how much this sentiment is reflected in the process of block printing. Adapting to the nature of your print as you work is essential to the outcome of your pattern. You must work according to the idiosyncrasies of your block, the traits of your paper or fabric (and of your paints), and with whatever is happening as your pattern begins to build. Remember, no print will ever be exactly the same as the next – each will have its own character, qualities and perfect imperfections.

It's also important to be open-minded to the fact that the final print may not look exactly like your first sketch. Try to embrace the fact that block printing is a working process and don't commit too much to your original design – remember the initial idea is only the start of your design journey. It's the final print (the 'destination') that's important. Having said that, you'll find that the more you practice, the easier it will become to imagine your finished pattern.

Here are some of nature's colours that inspire me.

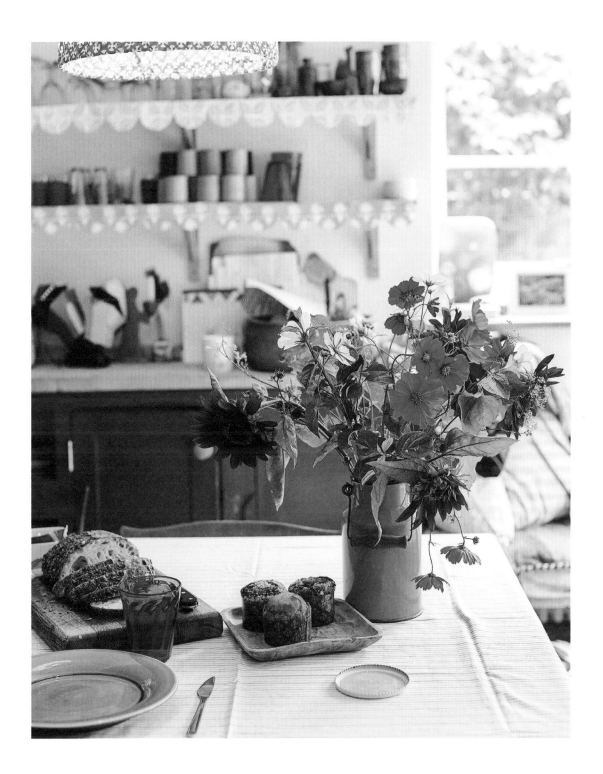

NATURE'S GREEN

Moss green, grass green, apple green, olive green… nature's signature colour has the most wonderful collection of shades. People are afraid to use green in their homes, but I often wonder why. For me it's the most neutral of the colour spectrum and so reflective of our outside surroundings. As we spend more and more time indoors, I think it makes sense to bring some green inside with us.

I love to print with greens, and one of my first designs (and the first wallpaper I ever block printed) was the Birds & Bees pattern using Farrow & Ball's 'Arsenic' green paint (see page 87). The pattern, featuring natural elements, including birds, bees, ladybirds, butterflies and honeysuckle, was originally printed to decorate a friend's shepherd's hut but inadvertently kick-started the Molly Mahon company as it exists today.

DESIGN NOTES

Natural greens work really well with pinks and blues. I decorated the spare room in our Leaf wallpaper in grass green and paired it with the room's inherited blue curtains (they were already here when we bought the house) and my block-printed indigo cushions.

MUD BROWN

This is one of the oldest colours ever used, and its 'earthy' tones make it the perfect shade to signify nature. Similar muddy shades like ochre, umber and burnt sienna are often dismissed as dreary, but I have been mixing some deliciously rich tones of brown recently, and am particularly excited by how they sit on natural cloth. They complement one another and offer a lovely option for someone who wants to keep within the bounds of a neutral palette.

In Bagru, they print using a process called *dabu* – this is generally done by the women of the village and is fuelled with banter and chitter-chatter. The traditional technique (also discussed on page 36) uses a paste, made from local mud, that works as the 'resist'. The resist clings to the cloth and prevents the dye from permeating the fabric when it is plunged into the dye. This is nature at work in its truest form.

DESIGN NOTES

I think I have overlooked brown as a colour in the past, but the more I work with it, the more I see its beauty and variety. I have learned to embrace colours that I'm not familiar with to see where they take me.

Shades of brown offer a sophisticated way of introducing patterns in neutral tones, and are particularly good for those who love pattern but aren't looking to add bright pops of colour.

SECOND NATURE

I am lucky to have been brought up by parents who were captivated by the natural world – they grew vegetables, kept animals and knew the name of every tree, bird and butterfly. For this reason, out of all the sources of inspiration I look to for my work, I think nature will have the greatest longevity and the strongest hold over my designs. It's an instinctive source of creativity for me, and I can't imagine ever tiring of patterns inspired by flora and fauna.

As we have seen, so many designs can be traced back to patterns in nature – the beauty of honeycomb, waves on the sea, spirals in a shell, stars in the sky, the moon, the sun, the layers of leaves in the trees. We need nature to survive and we are ever more aware of its importance for the sake of a healthy planet. It feels poignant to celebrate and revere the power of nature, and I encourage you to use it as your first port of call on your own design journey.

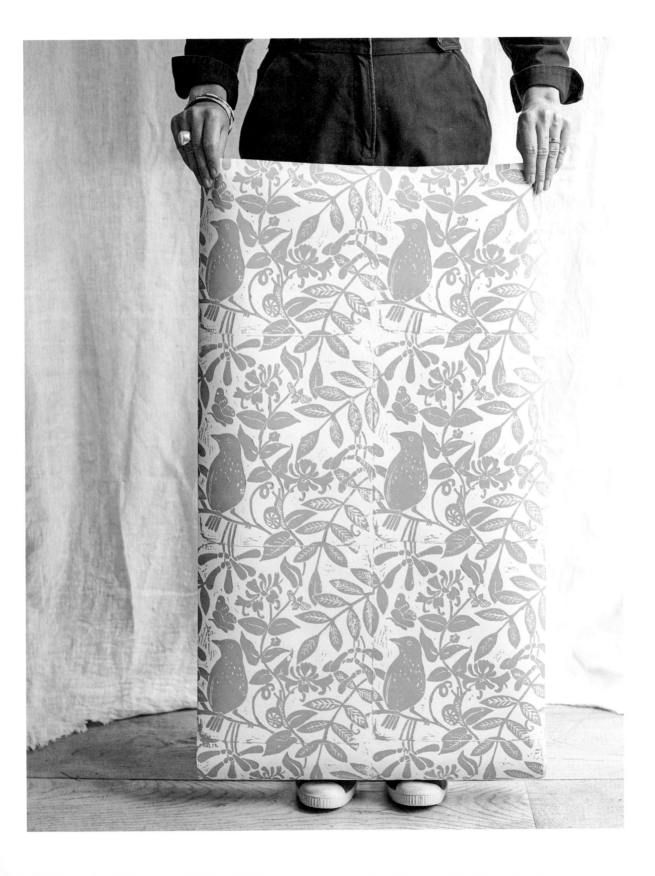

INSPIRED BY...THE BLOOMSBURY GROUP

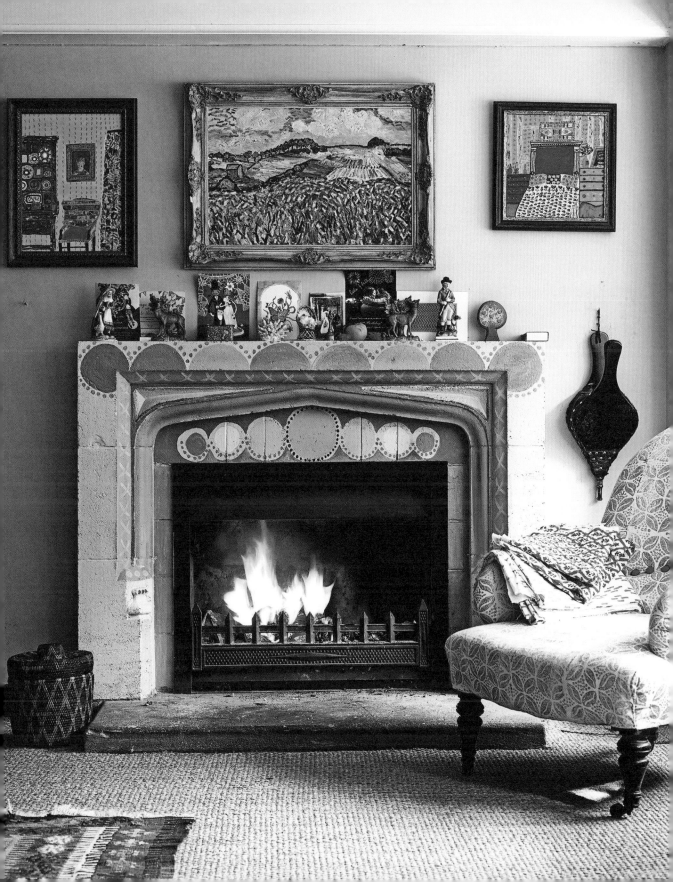

In 1905, a fascinating coterie of artists, intellectuals and writers, including writer Virginia Woolf, the painters Duncan Grant and Vanessa Bell (Woolf's sister), art critic Clive Bell, and novelist E.M. Forster, began to meet at Vanessa's London home. Sharing ideas and encouraging each other's creative pursuits, the pioneering circle became known as the Bloomsbury Group.

Maybe it is because Charleston Farmhouse, their country home and meeting place, is just down the road from where I live, or perhaps it's just the way they decorated their houses, but the Bloomsbury Group, and Vanessa Bell in particular, have had an enormous impact on my work. Their wild tales of love and lust and their political views are compelling, but it's the freedom with which they created a sense of 'home' that really mesmerizes me.

In *Rooms of their Own*, Nino Strachey concluded that, 'Their distinctive combination of bright colours, abstract patterns and eclectic objects gives a joyful feeling of comfort and informality', and this is exactly the feeling I try to create in my own home. I can't think of a more successful or envy-inducing house than Charleston. Nestled in the South Downs in East Sussex, with the light reflecting off the sea, it is not only a restful and peaceful retreat from London, but the perfect residence for a painter. Here the group poured as much love into the walls, furniture and household pieces as they did their canvases.

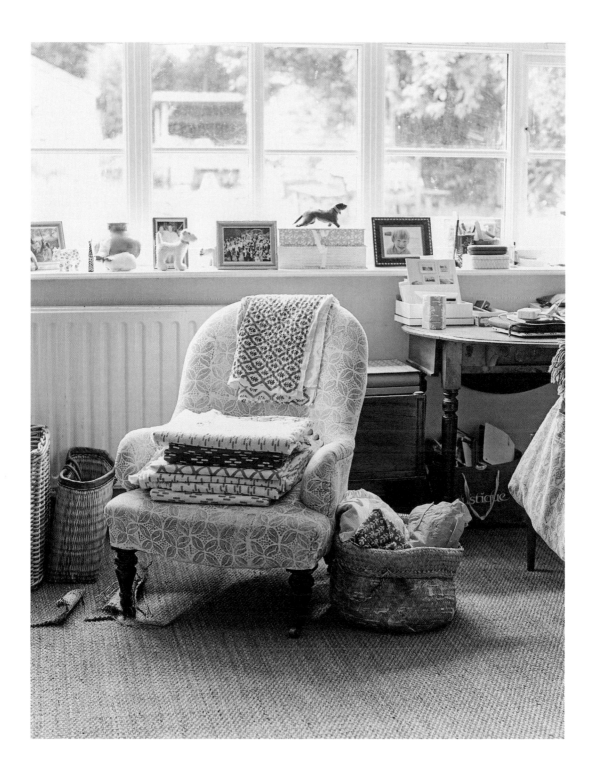

CREATIVE FREEDOM

The artists that belonged to the Bloomsbury Group were rule-breaking non-conformists, who encouraged each other to push boundaries, and to be free from anything run of the mill. They believed that art was available to all and were not precious about the way in which it was used. It was this freedom to experiment that perhaps led them to paint and apply pattern to any available surface, from walls and doors to curtains, tapestries and lampshades.

They worked with a liberating confidence and often decorated, as Virginia Nicholson noted, 'rapidly and without due preparation'. I love this sense of abandon. We are all so caught up in what we 'should' do, or with what people 'might' think; I draw upon Vanessa's fearlessness (I like to think she was the leader in all the decorating) as I, too, go about stamping my mark on my home.

Many people had lived in our cottage before we arrived – the first part was built in the 1600s. Since then, countless alterations and adjustments have been made to suit those that found themselves here. Being bold in my personalized approach has enabled me to decorate the space in a way that reflects the true personality of my family. It's now a home where we all feel able to create, reflect, relax and grow.

The mindset of the Bloomsbury Group empowered me to follow my heart and do what feels right to the house – whether that meant painting the fireplace, embellishing a cupboard door, or printing fabric for my curtains. By using the practice of block print you too can enjoy this creative freedom to decorate, and in no time you could be creating your own lampshades, curtains, cushions and more.

PATTERNS AND PALETTES

Vanessa Bell and Duncan Grant's freedom to express themselves at Charleston was prolific and inspired. Their house was a place to be carefree, to entertain and enjoy life and, most importantly, to feel 'at home'. Their designs often celebrated the beauty of nature and the animals they loved, and frequently showcased the charm of repeated patterns across walls and fabrics. Their mix of simple geometrics with vases of flowers and bold marks created an interesting yet harmonious feel that I have tried to re-imagine in my own home. For instance, in my living room and bedroom, I have mixed soft and earthy tones with splashes of bright pink and orange.

A walk through Charleston Farmhouse is like falling down a kaleidoscopic rabbit hole – when you come out on the other side you will never look at decorating your home in the same way again! Bell and Grant's laissez-faire approach and willingness to disregard the rulebook is irresistible. There's no holding back, and the result is a fantastic multitude of patterns and colours. Classic Charleston motifs include circles, cross-hatch, squares, arrows, arcs, petals, lines, dots and dashes. It's the ultimate pattern bible, and a true feast for the eyes.

Their home has also been a massive source of colour exploration for me. From deep greys through chalky blues, vibrant greens, warm pinks, delicate mauves and golden mustard tones, there was barely a colour they didn't experiment with. And there were certainly no rules as to what went with what, which often resulted in a cacophony of colour all in one space. Perhaps this incredible palette was the beginning of the 'more is more', maximalist approach…

Overleaf you'll find some of the shades from the Bloomsbury Group's colour palette that have inspired me.

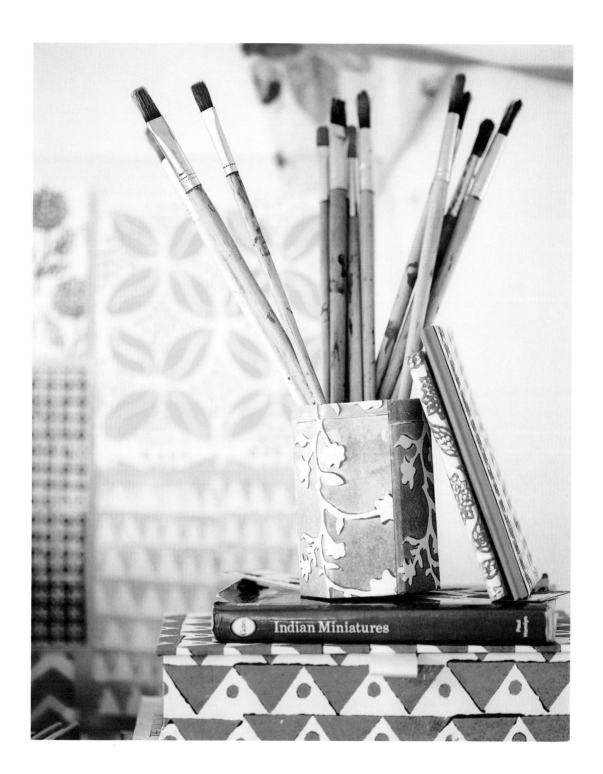

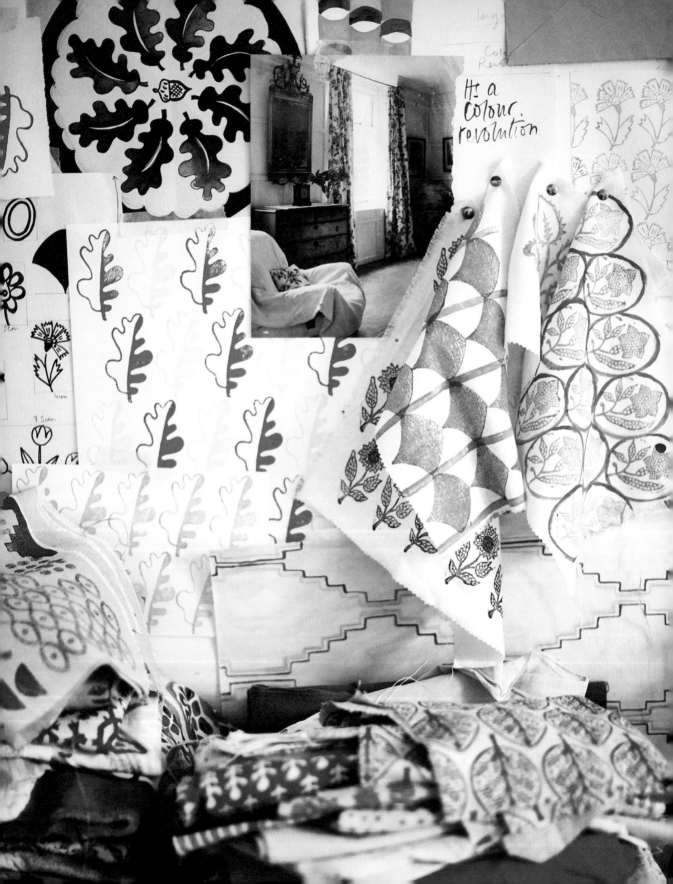

It's a colour revolution

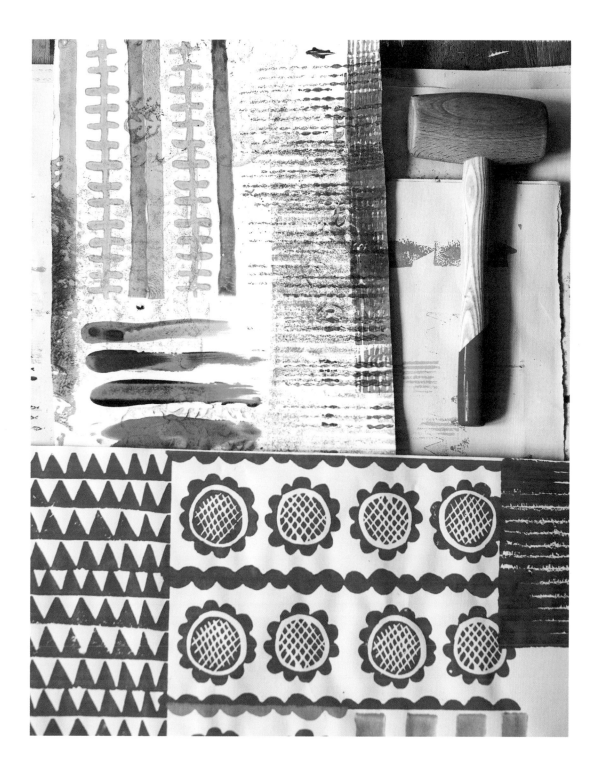

PASTEL PINK

This is a colour I am really keen on at the moment. It is soft and delicate and, when combined with shades of plaster of Paris, it can also take on a rustic, even earthy tinge. The front door of Charleston Farmhouse is this colour, with a band of blue-grey around the frame. It's instantly warm and welcoming, and reveals only an intriguing, subtle nod to the treasure trove of colour inside.

The area surrounding Vanessa's open bathroom is painted in pastel pink. I think when candles were lit (bearing in mind that the farmhouse would have been very cold at times), the shade would have created a cocooning atmosphere while she bathed.

DESIGN NOTES

Embrace pink and don't let tired, stereotypical interpretations of the colour hold you back. Pink is a powerful and sophisticated shade. My son's room is decorated in my Spot & Star wallpaper in pink and it's one of the cosiest spaces in our house. Who wouldn't want the striking, inviting, comforting space that pink creates?

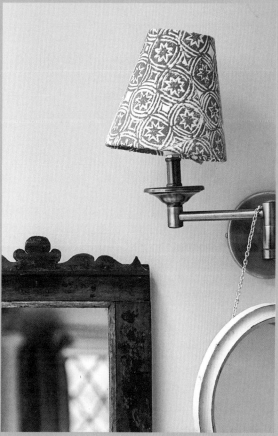

GREEN DISTEMPER

I love this earthy yellow-green, and the Bloomsbury Group mixed this colour particularly well. The distemper around the top of the wall in Vanessa Bell's study, and the completely green bathroom added in 1939 for Clive Bell, are two lovely examples of the shade at Charleston.

Though we may not dare to paint a room or even a wall in this beautiful hue, it's a fab colour to print with (and to celebrate!) on some napkins or a cushion.

DESIGN NOTES

In our bathroom, I have used our Coral wallpaper in green. It's energetic, but the pops of pink from the fabric lining the cupboard doors work to soften it. It's a joyful combination.

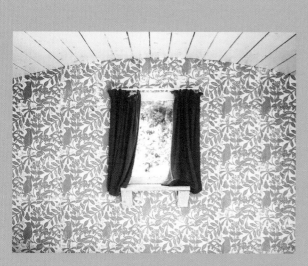

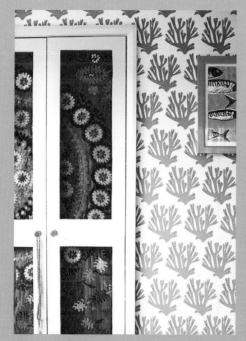

BLOOMSBURY BLUE

A pastel blue-grey is perhaps a less obvious choice for Charleston, but it is very much in evidence on the gate as you arrive at the house, on the front door frame, the bed frames and in the paintings. It's a lovely, passive colour that allows other colours to show off. It's a great shade to print with for those seeking a more subtle result!

We painted our kitchen units in a similar pastel blue-grey. It's so easy to live with all year round – cool in summer and warm in the winter – and it's a shade against which my hot pink curtains and colourful crockery collection can really pop!

DESIGN NOTES

Pale or bright, warm or cool, bold or soothing, there's no denying that blues are beautiful. My school uniform was navy and for a long time I stayed away from the colour, seeing it as institutional and plain. However, many moons later, I find I live in navy blue – it's my black. It's the perfect backdrop for my colourful range of scarves as well as being my printing uniform (I live in navy boiler suits and blue cotton dungarees).

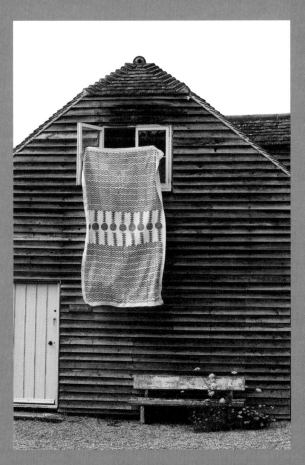
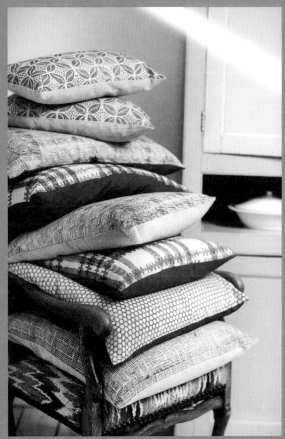

PAST AND PRESENT

Even though I often look to the past to spark my creativity, it's important to me that I am designing for the present. I may fill my mind to the brim with the patterns, colours and textures I have collected from Charleston Farmhouse, but where I take that inspiration on my own design journey is very individual, and this is where the story becomes unique to me. The art of block print is ancient, but what I create will be new and intended for today.

The Bloomsbury Group inspires me to cover surfaces in pattern, India inspires me to use bold colours, and nature inspires me to celebrate its shapes – I take all of these ideas on board when I am creating my prints. Perhaps the most powerful impression Vanessa Bell and Duncan Grant have made on me is the importance of making confident creative choices fuelled by joyful abandon (rather than cautious decisions made with fear of failure or judgement). A perfect example of this is a shepherd's hut that I decorated for a great friend of mine. Lisa and her family wanted it to be playful in spirit, and a fun, welcoming space. I was in my element and drew upon all my sources of inspiration to arrive at the end result…

We chose a plum paint for the outside and turmeric for the door and floor. We paper-backed my Marigold fabric to create a textured, soft wall covering. We painted the sleeping area powder pink to encourage a soporific, cosy space to bed down in. The ceiling was painted in stripes of blue and yellow to bring out the colour of the walls. Finally, we made homespun curtains with indigo-dyed cloth and added a hint of luxury with little gathered lampshades.

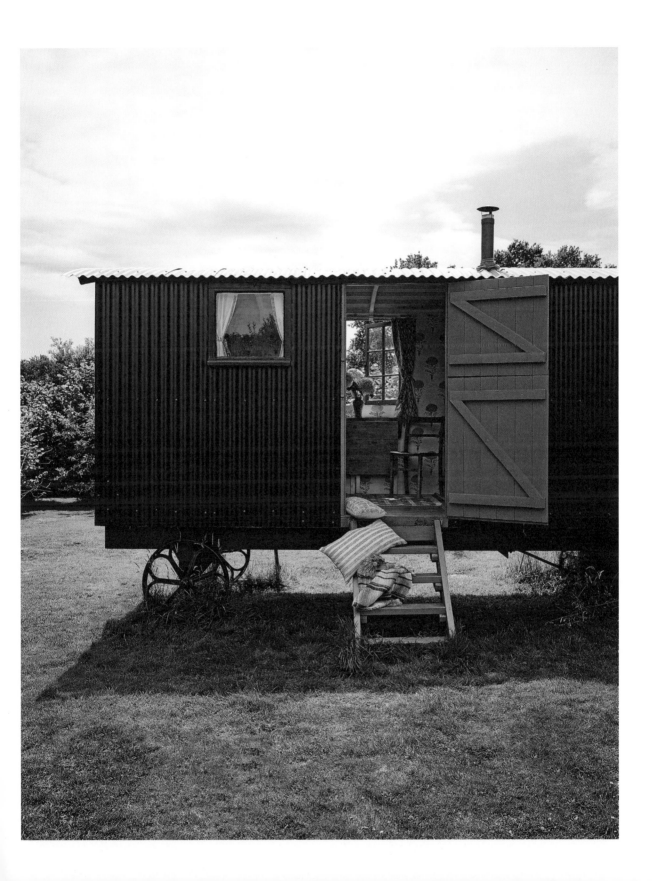

THE IMPORTANCE OF HOME

I have been making spaces feel like home for as long as I can remember – long before I had one to call my own. For years I rented a room from various friends in London. The first thing I would do was decorate it and make my mark where I could. I would rearrange the furniture, drape fabrics over chairs, and paint the walls (if I was allowed). I was never concerned about how short a time I might be there, this 'room' was my space amongst the chaos of London life and I wanted it to feel like my own.

Eventually I got my own home with my now husband, Rollo. I couldn't wait to start decorating it. This was what I had dreamed of, my OWN home – followed quickly by marriage and a small gaggle of children! So determined was I to have an upstairs and a downstairs that we bought an absolute matchbox of a house, much smaller than most flats, but it was OUR house. This quickly became a very special place to us; we built many memories in the time we were there, and when we moved to Sussex, not only did we have lots of furniture, but we also realized that HOME was something fundamental to creating a sense of safety,

memories, happiness and cheer. So much so, that on my list of priorities I put decorating our second house way before taking a holiday or buying new clothes.

We have been in our cottage for nine years now, and it is the anchor of family life. Orlando was born in the bath here, I recovered from endless operations and chemotherapy here, we have celebrated birthdays, we have moved stairs, painted, wallpapered, laughed, cried and LIVED here. There is no other place on Earth that could be more sacred to my family than this little oasis in the forest, and I still believe that creating the right home for you is one of the most important things you can do.

I love colour and pattern – lots of it, all together! I find a room full of textures, layers and colours is exciting and uplifting. I want my house to be cheerful and warm. Block printing fabric and wallpapers, painting with beautiful hues, decorating doors with flower prints… each act of creativity has enabled me to add personality and charm to our house. When people come to visit they always mention how welcoming the space is.

Homes should be a reflection of their inhabitants – of us! We need to personalize them and not be afraid to have them as we truly want them to be. Real homes are not showrooms or magazine- or Instagram-ready rooms. Real homes are spaces to be comfortable and relaxed in. They need to be user-friendly, but most importantly they need to feel happy and enticing.

A good lashing of cheer is so important. Through the difficult times (and we have certainly had those) 'coming home' should be something to look forward to. Whether returning from a long journey, a tough day at work or a wet grey fog – there is nothing more uplifting than a joyful home.

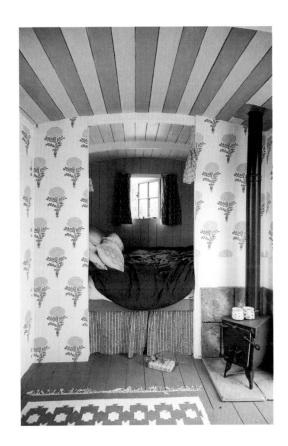

MAKE YOUR MARK

Block printing has a long and fascinating history. For me, the fun in designing comes from looking at how to use these time-tested techniques to make something for today. Like a hoarder with an enormous basket, I collect colours, patterns and shapes while walking in nature, travelling across India, and revisiting places like Charleston Farmhouse that have been suspended in time.

We are all creative and we can all embark on our own design journeys. We all need to create to express ourselves and when we do, we will make something unique. We can look at the same leaf, but all our drawings will be different. We can stand in the same amazing palace in India, but we will all notice something different. We can look around Charleston, but we will all feel something different. Creative beauty lies in this individuality, and this is also where the joy of block print can be found.

When our fabric orders arrive from Jaipur, I am learning to recognize who printed a particular fabric simply by the marks, the tell-tale signs, left by the printer's hands. These marks are what make this craft so special, and in the next part of the book I want to show you how you can make your own mark – and your own block prints!

You'll find everything you need to get started at your kitchen table. You could make a cushion or some curtains, and who knows, they may still be hanging there in 50 years, telling a beautiful story and inspiring others to keep the craft of block printing alive. Most importantly, they will be something that YOU have made, and the pride you can take from that is tantamount to joy.

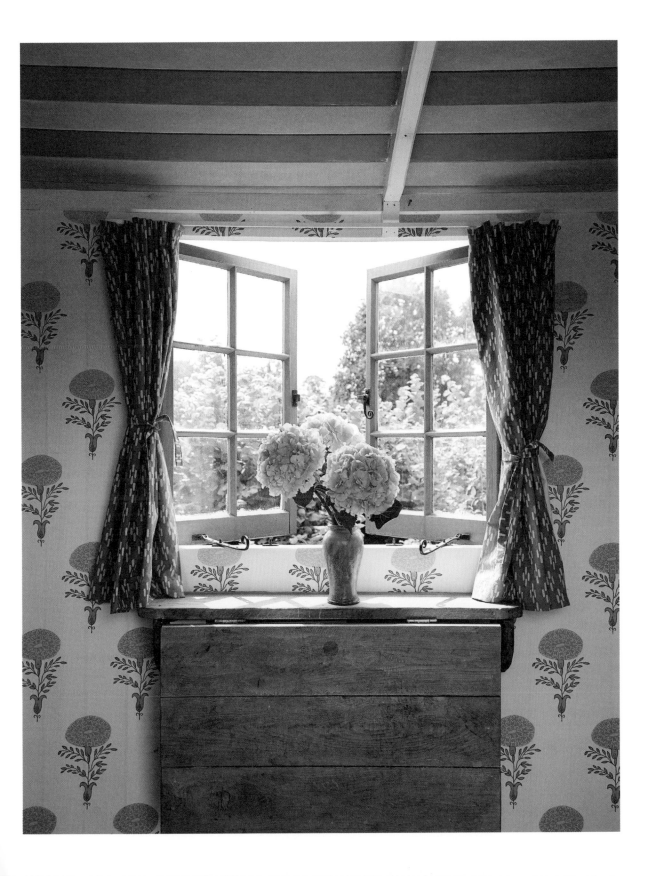

PRACTICAL PRINTING

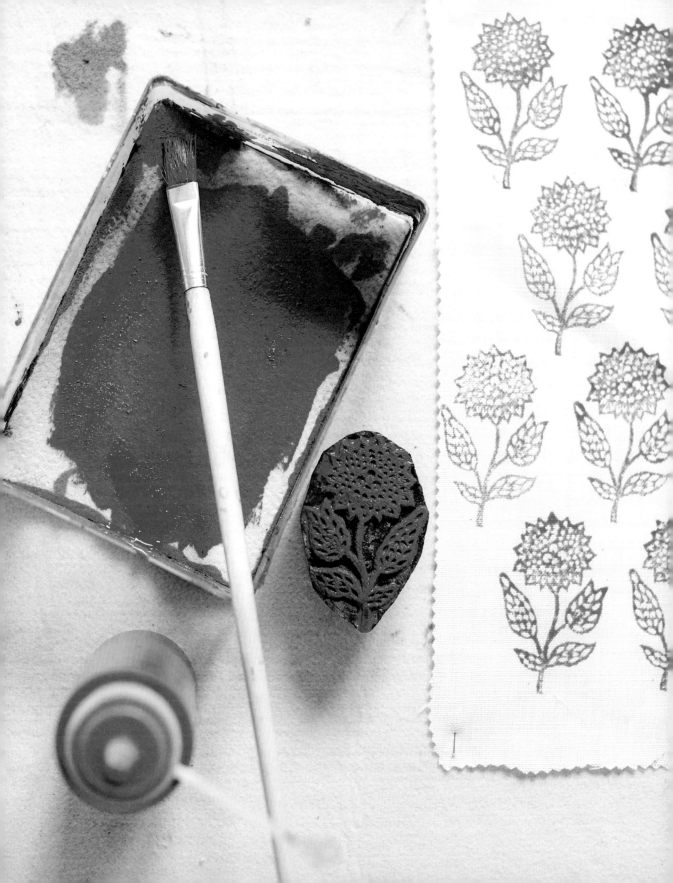

How do I commit to my final block print design? I am asked this all the time. The answer is trial and error. I have piles of drawings, sketch books, and sheets of tracing paper filled with patterns in all manner of scales, some coloured, most just pencil. The more you doodle, the more you start to learn what works, how to place the pattern, and how a repeat works.

One great tip is to keep it simple. I don't make highly intricate patterns with hundreds of colours, I print very simple impressions of my surroundings. In the Nature section I showed you how I took an oak leaf and just drew around it (see page 74). For anyone feeling anxious about putting pencil to paper, that is a great place to start.

Inspiration can be found anywhere – inside, outside, in a museum, in nature books, exhibitions, architecture – you just need to stop worrying about the bigger picture and hone in on the small details. Put a notebook and pencil in your bag and use them to sketch something you see. Remember, keep it simple.

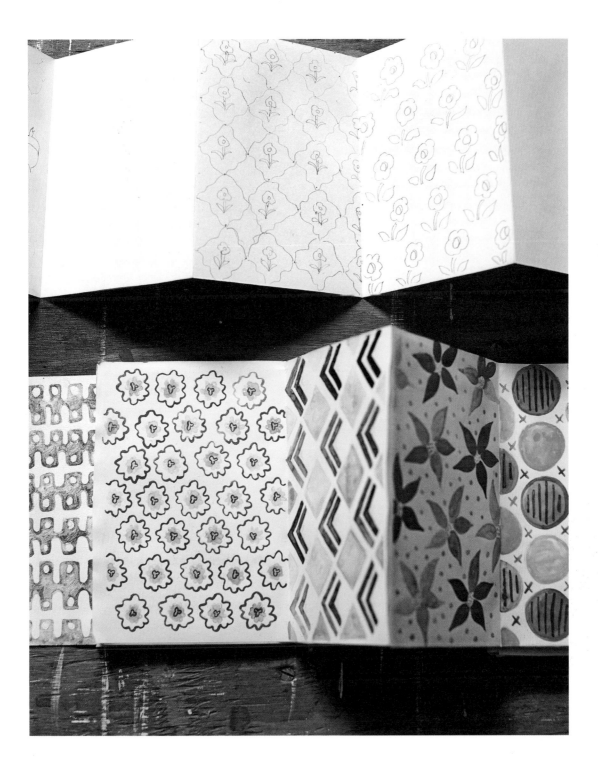

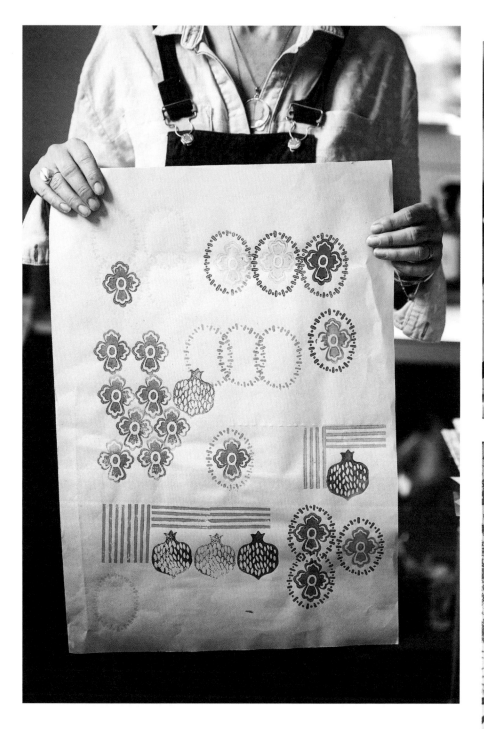

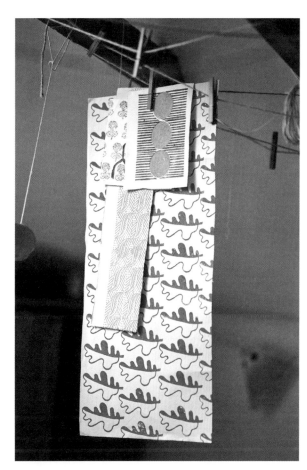
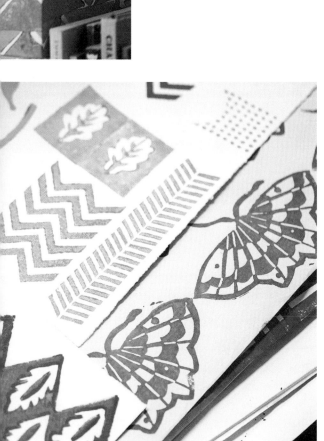

TOOLS

Here's a checklist of some things you'll need to get printing, plus some helpful notes.

1. Tracing paper
2. Printing paper (or fabric)
3. Lino block, or alternatively…
4. Rubber block
5. Lino cutting tools
6. Table padding
7. Printing pad
8. Paintbrushes
9. Paint and sauce bottles
10. Pencil
11. Apron

Plus…
a strong, sturdy table, an old sheet, pins or masking tape (optional), a towel and an iron

Tracing paper – tracing paper allows you to play around with your design and will help you imagine how the final pattern will look. You can also use it to transfer your design to the block (see page 122).

Printing paper (or fabric) – you can print on virtually any type of paper, just have a play and experiment. Some papers absorb paint better than others, or have a texture that adds to the print. I always have a stash of recycled sugar paper to test out my designs. It's absorbent, you can buy large, inexpensive sheets, and as it's recycled it gets an eco-friendly thumbs up – so it's pretty perfect to practice on.

Lino, rubber or wood blocks – lino is made from linseed oil and cork or wood shavings. There are various qualities available. The original grey variety is very hard to carve when cold. Once warmed up it becomes much more manageable (I warm mine near the radiator or by placing it under the bulb of a desk lamp). You can buy lino in a range of different sizes, and even on a roll. I recommend you start with rectangular pieces that are pre-mounted onto fibreboard blocks – this will give you something to hold on to when you are printing. Rubber offers a modern alternative to lino. It's cheaper to buy and easier to carve, so it's brilliant to practice with, and great if you're just starting out. However, you won't achieve as 'sharp' a cut as with lino. Alternatively, if you are really uncertain about carving your own block, you can buy wooden blocks featuring lovely designs from online retailers.

Lino cutting tools – there is a huge selection online. Opt for tools with wooden handles if you can. You can also get handles with a selection of blades that can be swapped over. There's a huge price range,

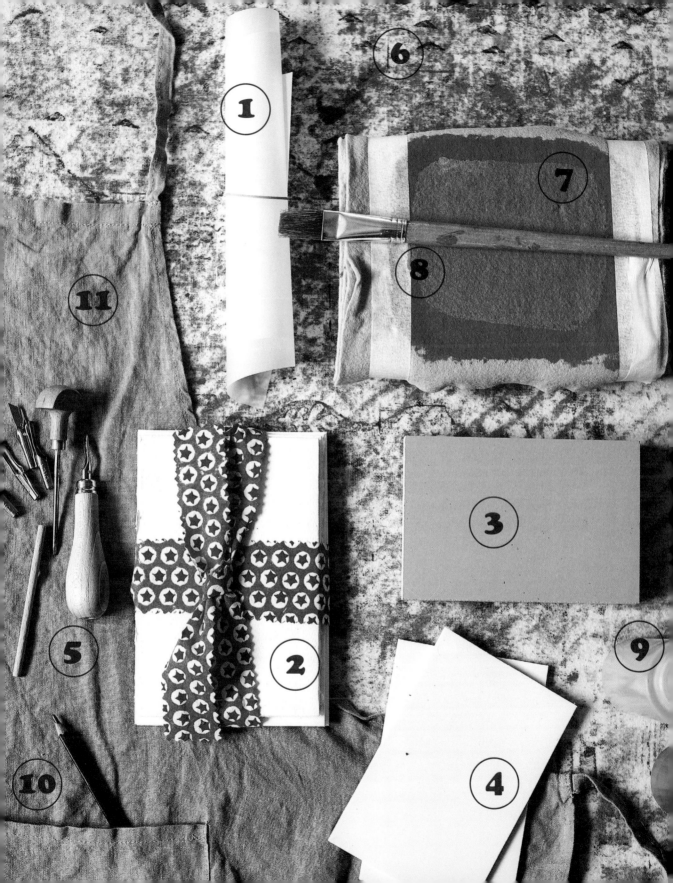

from basic budget options to premium Swiss-made Pfeil cutters, which I love. (Pfeil tools are an investment, so I usually ask for one every birthday or Christmas!)

Table padding – you can use wool felt, an old blanket or rug, or layers of newspaper. But why is padding important? If a block hits a solid table, the block will 'jump' and you won't get a clean print. Covering your table with a layer of padding will absorb the impact, and allow you to transfer your print onto paper or fabric successfully. Once your layer of padding is in place, smooth an old sheet over the top to create your work area.

Printing pad – sheets of wool felt create the perfect printing pad for you to evenly load your block with paint before each print. To keep mess to a minimum, I often cut the sheets to size and place them inside plastic containers to create a paint tray. (You can also seal the containers with a lid to prevent the paint and pad from drying out if you need a break from printing.) It's important to create a pad with a 'springy' feel to allow the block to absorb the paint efficiently, but don't make the pad too thick – if you use too much, the felt will simply absorb (and waste!) your paint. I use 4mm-thick sheets. To create a pad with a large surface area, wrap sheets of wool felt around a large block of wood (see page 146).

Paint – you can buy block printing paint specifically for fabric, which is especially important if you're planning on washing the finished piece. You can experiment with any type of paint – now you can even print

(see page 146).

HANDY TIPS

Mixing your paint – I use sauce bottles to mix my paint. It makes it very easy to apply it to your printing pad as you can just squeeze it on. Most paints are very thick and can look gloopy on fabric, so water them down. Add one part water to three parts paint for fabric, and one part water to four parts paint for paper. Aim for a creamy consistency.

Disposing of paint – it's important to dispose of leftover paint responsibly. Always wipe off as much leftover paint as possible from your tools and print area, then wrap it in newspaper and throw it in the bin. Rinse your tools with cold water (warm water will cause the paint to set).

fabrics with chalk paint and it stays put once set with heat. I do however urge you to only use water-based paints. I am especially keen on a brand called Permaset that has the Soil Association stamp of approval.

Paintbrushes – I use these to smooth the paint across the printing pad. I also always have a dry one nearby to clear out the block if it looks like it's getting clogged up.

Strong, sturdy table – you won't get a successful print if the table is wobbly.

Iron – always use a dry iron to set the paint (see page 127 for more information).

Towel – I like to have one hanging out of my pocket so I always have it to hand to contend with paint-covered fingers.

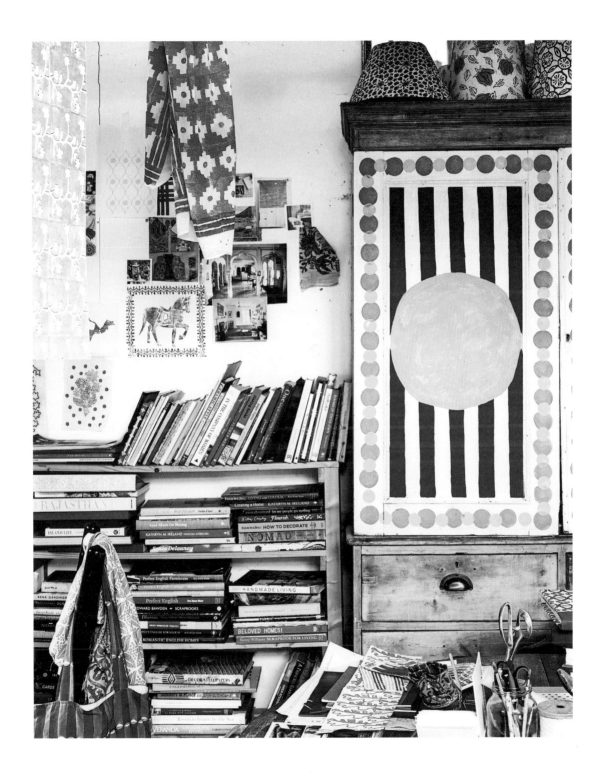

PREPARING THE PATTERN

TYPES OF REPEAT

Once you have sketched your design, it's worth bearing in mind that there are different ways you can print with it. Without getting too technical (there are lots of great books out there that do just that), I will outline three methods to start you off…

SIDE REPEAT

This is the simplest way to print and the method I generally stick to. Simply print from left to right in straight lines, placing the block directly to the right of the last print, and then directly below when you start a new line. If you're left-handed, it will be easier to work in the opposite direction.

DROP REPEAT

In order to make the repeat less obvious, a drop repeat can be used where the second placement of the block is printed halfway down the right-hand side of the first. Then the third print is realigned with the first.

RANDOM REPEAT

This is where the pattern appears to be random, but is actually well thought out! It creates a lovely, tree-flowing effect.

GO WITH THE FLOW

As well as different types of repeat, you also need to think about how your design will flow across the paper or fabric.

To make a design flow across from one printed block to the next…

Cut a square or rectangular piece of paper, ideally the same size as your printing block. Draw a shape in the middle, then cut the piece of paper into four equal pieces – make sure you cut through the centre of your design. Move all the pieces of paper around so that the drawn-on pieces are on the outside corners, then turn the pieces over and tape them back together. Turn the piece of paper right-side up and fill in the centre space again. When you start printing, the edges of your design will connect and make your pattern more interesting.

Alternatively, when you are drawing the pattern, draw marks on both sides of the block so that it starts and finishes at exactly the same place – the design will then 'connect' when printed side by side.

PREPARING THE BLOCK

Trace your design onto tracing paper (see page 116). Position the tracing paper over the block and transfer it onto the face of the lino. Remember that your print will be the reverse of whatever you trace onto the lino. This is especially important to remember if your design includes lettering.

Once you have drawn your design onto the block, you need to be sure about the sections you are going to carve away. Fill in the part that you want to transfer to the paper or fabric (the positive area of the design) with a black pen. The illustrations here show two options.

The first (below left), is where I have chosen to keep the flower and leaf impression as the area that will be printed, i.e. the flower and leaf is the positive area of the design. In the second (below right), I have carved the petals away so that the background becomes the positive space that will appear in the colours I choose to print with.

A good way to start is to carve a design (running from edge to edge) onto a piece of rectangular lino that has been pre-mounted onto a fibreboard block. This is handy if you want to practice and play with positioning, as you can use the edges of the fibreboard to line up your design and make sure it's nice and straight when you're printing.

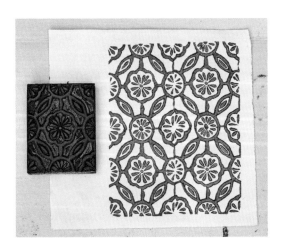
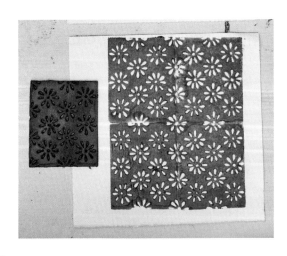

CARVING THE BLOCK

With your design traced on the block, and the positive area of the design (the bits you want to keep) coloured in black, you can start to carve away the negative space. Warm the lino first if you are using the grey variety (see page 116 for tips). Remember, don't worry if the pattern looks back to front before you start – it should be! When you come to print with it, it will right itself again.

ALWAYS carve away from your body, make sure your tools are sharp and never be tempted to hold the top corner of the lino, thereby placing your hand in danger. You can buy a lino carving protector as an extra precaution. Carve slowly, smoothly and carefully until all the negative areas of your design have been removed. Your block is now ready for printing!

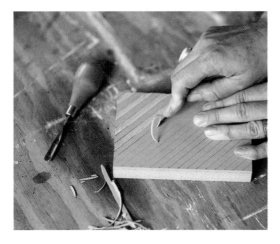

IMPORTANT

ALWAYS carve away from yourself, and never hold the top corner of the lino with your fingers, thereby placing your hand in danger.

WHICH TOOL TO USE?

There are lots of different cutting tools with different sizes and shapes. I like to use a narrow V-shaped tool for carving the initial outline of the design, and a wide U-shaped tool for carving away larger areas.

HOW DEEP SHOULD YOU CARVE?

You probably won't know until you're printing whether you've made deep enough cuts to completely remove the negative areas of your design. You need to carve until the negative areas (see opposite page) disappear when you print. You may find initially that specks appear across your print where the negative areas haven't been carved away completely. This can add a lot of character to your print, but if you're looking for a very clean finish, wipe your block clean and continue to carve away the negative space.

GET PRINTING

The key to a good block print is good foundations. If you're organized, you're less likely to make a mess! First, clear a large, solid work surface. If you think you are going to do lots of printing, make sure you are comfortable and your table is at a good height. I'm tall and my printing table is up on bricks so I am able to stand quite straight as I print – you don't want a sore back at the end of the day.

Wear old clothes and an apron you aren't too bothered about. Lay your padding down (see page 118), then smooth an old sheet over the top. Make sure everything is completely smooth. You don't want any creases in the sheet – any lumps and bumps at this stage will show up in your printed design. Lay your equipment to your left side if you're right-handed and to the right side if you are left-handed.

PRINT ON PAPER

Always practice on a scrap piece of paper until you've got your eye in. When you're ready to print, lay your paper down on the table. It must be completely flat with no edges hanging down in front of you in case you lean in and crease them.

I am right-handed and I like all my tools and paints to be on the left of the paper. I lay out my felt printing pad, the sauce bottle containing my prepared paint (see page 118), my paintbrush (with a little plate to rest it on) and, of course, my block.

Shake your paint bottle well, remembering to put your finger over the top before you do – otherwise you might give yourself a Jackson-Pollock-style makeover! Gently squeeze a little paint onto the felt printing pad, then smooth it out, using your paintbrush, to create an area slightly larger than your block.

To start with the pad will absorb a lot of the paint so keep adding small amounts until you have a happy balance – not too dry and not too wet – this will make sense once you start. It's important to add the paint slowly. The worst thing you can do is overload your printing pad, as the block will become full and messy and you won't get a clean print.

Once the paint has soaked in, place the block gently onto your printing pad (don't push it down), then lift the block off the paint. Try and keep your hands clear of paint to avoid the potential for smudges.

Take a deep breath, look directly down over the table, and carefully commit the block to the paper. Push down fairly hard, then with confidence lift the block straight up and off the table. Reload the block with paint between each printing and try to print with consistency – this is really down to practice. (This is why I always suggest you start by printing an entire sheet of sugar paper. Not only does this get your eye in, but it means the pad and the block will be ready to go and will allow you to achieve a more consistent, polished finish.)

Continue the process until your pattern is complete. Ta-dah! You have just turned something plain into a thing of beauty. I get excited even when writing about how to block print, it really does bring so much joy as you fill the canvas. Remember to keep breathing, enjoy the repetitive movement, and try and get into a flow. It can become quite meditative and before you know it time has flown by and you've forgotten to collect the children from school!

PRINT ON FABRIC

This technique is the same as when printing on paper, so read the instructions on page 125 before you get started.

You may find, depending on the fabric you are printing on, that you might need to adjust the consistency of your paint. This will take a bit of trial and error, so I recommend having a practice on a few test pieces first.

Before you print on fabric you need to prepare it so that the paint takes really well. Whether it's a new piece of material or something well-loved, wash it at the highest temperature it can take. This knocks out any impurities or dirt that might be clinging to it, which can stop the paint penetrating the fabric. I like to use an eco-friendly, non-biological liquid or powder. Once the fabric has dried, iron out all the creases and you are ready to start.

Place the fabric on the prepared table so that the top corner is in the correct position for your first print. Pin the corners firmly in place, or use masking tape to secure the edges if printing with a small piece of fabric. Smooth the fabric out as flat as you can. When you're ready to print, follow the method on page 125. For advice on printing larger pieces of fabric, see pages 138–139 of the tablecloth project.

ADD LAYERS

Throughout this book I have shown you how to print with one colour, but a second or a third colour can certainly be added once you are feeling confident.

Here are some ideas to help you add colour…

Alternating the block – ideally it's best to have two, so you don't have to rinse the block each time you want to switch colours.

Alternating the rows – again it's best to have two blocks, so, for example, you can print a line of red leaves followed by a line of blue leaves.

Overprinting – either with the same block (think gingham) or with a different block, like using a small stick to add accents of colour to your main pattern (see page 153). Either way, make sure that your first layer has dried before you overprint the second.

Once you've got your head around this, there is nothing to stop you adding as much extra colour as you wish. Don't get overexcited and use too much colour all in one go. Personally, I find that a pattern printed in a single, bright colour is enough to make a strong visual impact.

SETTING THE PAINT

Whatever printed delight you've made, here are some tips on finishing up.

With printed paper, you are good to go as soon as it has dried completely. You can leave the paper to dry on the printing table or hang it up.

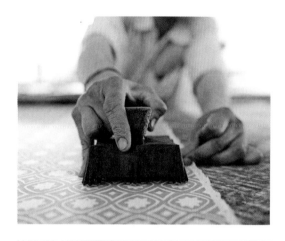

With printed fabric, if you think you might want or need to wash the fabric at some point, you have to set the paint. First, hang your printed items up, ideally on a washing line outside (weather permitting), and leave them to dry.

Once the fabric is completely dry, use a dry iron on the highest setting your fabric can take, and give it a good, long, gentle iron. The paint will continue to set over time, so try not to wash the item too soon.

The Permaset fabric paints I use are really good and robust and will last for a long time, allowing you to enjoy your printed pieces for years and years, until they become treasured heirlooms.

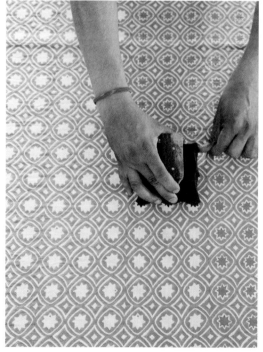

PROJECTS

So many things can be made with printed fabric and paper. Here I have chosen five of my favourite items to get you started. I often print onto existing items, but I have included basic making-up guides if you would like to create your items from scratch. While the same printing technique is used to create the foundation of each project, the tools required and the way in which the designs are created have been varied to illustrate the incredible versatility of the block print process (and the information provided in the previous chapter). Follow the advice on pages 116–127 before you start and you'll be up and printing in no time!

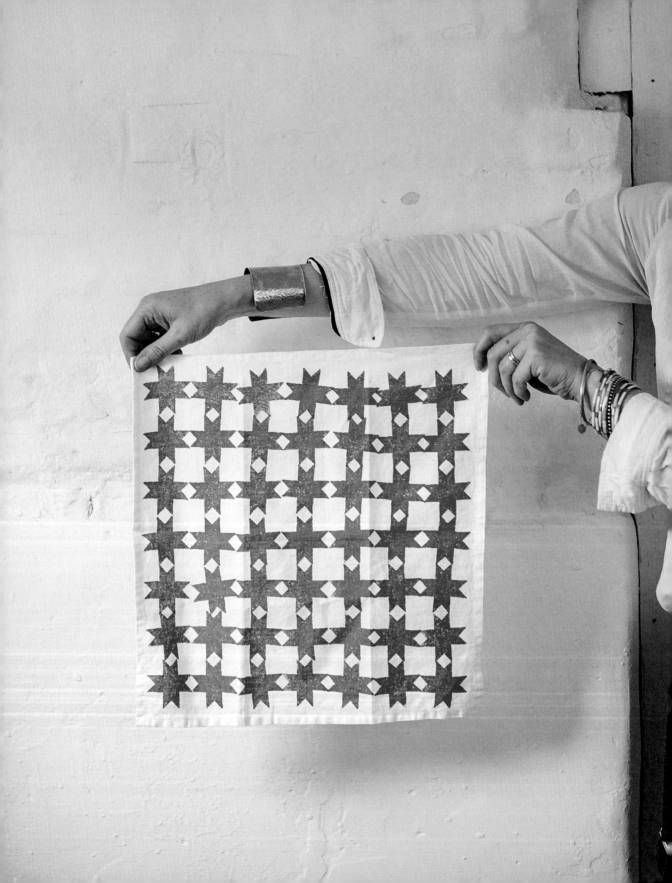

NAPKINS

These napkins were printed using a wooden block made in Jaipur, but you could easily carve a shape like this into lino pre-mounted onto a fibreboard block. The fun of a simple block design like this is that, as the print builds, it creates an additional pattern within the negative area of the design. You could use the same design to make a matching table runner.

table padding
old sheet
plain, hemmed, napkins
masking tape
sheets of wool felt, as
 required, to create a
 'springy' printing pad
plastic container with lid
fabric paint
plastic sauce bottle
paintbrushes
wooden block or carved
 lino pre-mounted onto a
 fibreboard block

Napkins are washed after every use, so it's important to pick a quality washable fabric. I bought plain napkins (in a cotton-linen mix), so they were already hemmed and ready for printing.

To create a napkin from a larger piece of material, cut a square of your chosen fabric to the size of the napkin, plus 3cm (1¼in) hem allowance on all sides. Fold and pin a narrow double hem all the way around. Using a sewing machine, stitch the hem to secure it in place – at each corner, stop with the needle down, lift the presser foot, pivot the fabric, then lower the foot and start stitching again. Repeat the process as many times as required until you have the desired number of napkins and are ready to print.

Wash your hemmed napkins at the highest temperature the fabric can take. Once dry, iron out all the creases, lay your napkin flat, then fold it in half horizontally and press a light crease back into the fabric. Lay your napkin flat, then fold in half vertically and press in another light crease. You should be left with a four-piece grid – this will help you find the centre of your napkin and give you four distinct printing areas. When you're ready to print, follow the instructions overleaf.

Once you have completed your pattern and the fabric is dry, set the paint by giving the napkins a long, gentle press with a dry iron on the highest temperature the fabric can take.

1. Place your hemmed napkin flat over the prepared printing table (see page 124) and secure. With a small piece of fabric, I often use masking tape to keep it in place as I print, but pins in the corners work just as well. However you choose to secure your fabric, make sure you smooth out any creases as you work.

2. Create a paint tray using a plastic container and wool felt for the printing pad. (Using a container with a lid means you can keep your printing pad sealed in between printings, which will stop the paint drying out.)

3. Pour the paint into the bottle and dilute with water until you achieve a creamy consistency (see page 118). Shake the bottle well, but remember to keep your finger over the top.

4. Gently squeeze the paint onto the pad and use a paintbrush to create an area slightly larger than your block. Once the paint has soaked into the felt, place the block onto your printing pad, then lift it off the paint.

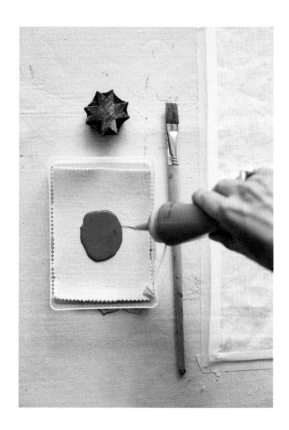

5. Carefully position the block over the centre of your napkin, using the centre point of your creases as a guide, then CONFIDENTLY place it onto the fabric. Give it a good push down. Take a breath and lift the block – do not hesitate! Repeat the process, moving towards the top edge, and loading your block with paint before every print.

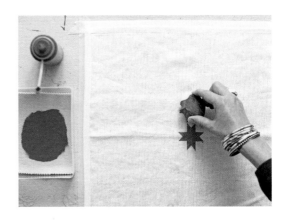

6. If you're right-handed, complete the print within the top left corner of the napkin, then complete the print in the top right corner. Repeat with the bottom corners. (Work in the opposite direction from top to bottom if you are left-handed.)

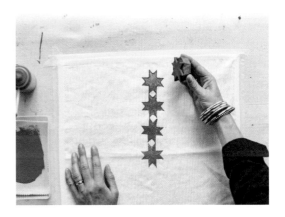

DESIGN NOTES

As napkins don't have a natural 'top' or 'bottom' position, I started printing in the centre of the piece so that I could achieve a symmetrical finish.

I could have continued to print over the sides of the napkin, but here I like how the design is framed by the hem.

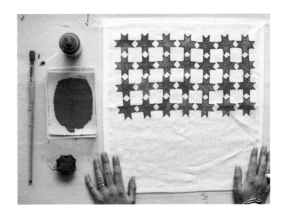

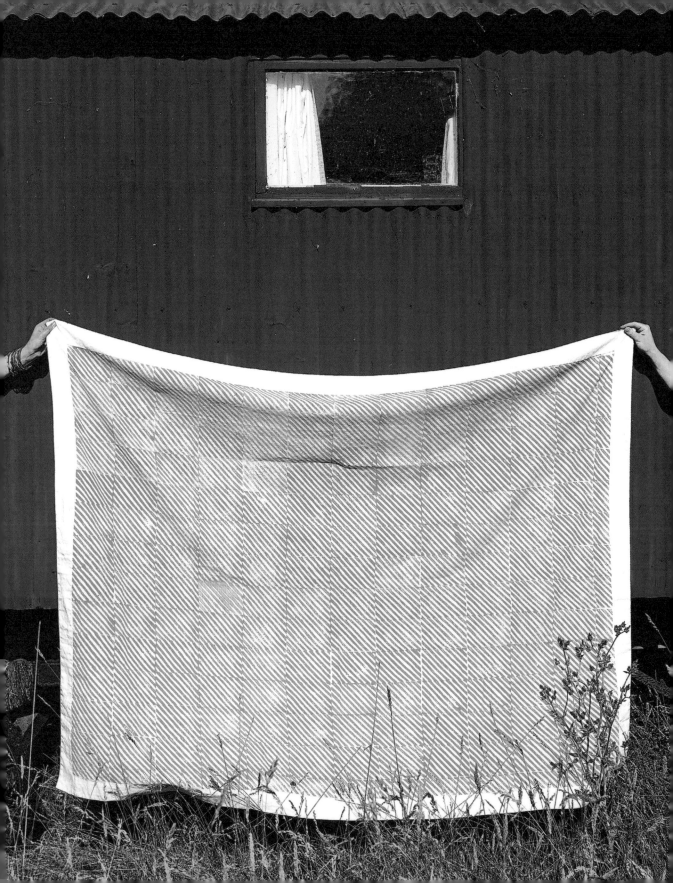

TABLECLOTH

You can easily re-purpose old sheets by printing on them and they make brilliant tablecloths! Alternatively, as I have, buy a plain tablecloth that's already been hemmed. I carved this design into lino pre-mounted onto a fibreboard block. The very simple stripe comes to life once printed across the expanse of the fabric. If you are concerned about the symmetry of your pattern, you will need to measure the cloth, measure your block, and plan for the best method of fitting the design within the printing area.

table padding
old sheet
plain, hemmed, tablecloth
pins
foam sponge
sheets of wool felt, as
 required, to create a
 'springy' printing pad
fabric paint
plastic sauce bottle
paintbrushes
carved lino pre-mounted
 onto a fibreboard block

Just like napkins, tablecloths might have to cope with a lot of thrills and spills, so make sure you pick a quality washable fabric. Here I bought a plain tablecloth that was hemmed and ready for printing. Alternatively, you can transform an old sheet, or select a plain fabric of your choice.

If you would like to make your tablecloth from scratch, first measure the length and width of your table. Next decide on the 'drop' for the skirt (the amount of fabric you'd like to hang over the table), and add that measurement, plus a 3cm (1¼in) hem allowance, on all four sides. If you're making a short-skirted tablecloth, allow at least 10cm (4in) for the skirt to drop, as any less will probably look too short. Cut your fabric to the required size. Fold and pin a narrow double hem all the way around. Stitch the hem to secure it in place – at the corner stop with the needle down, lift the presser foot, pivot the fabric, lower the foot and start stitching again.

Wash your hemmed tablecloth at the highest temperature the fabric can take. Once dry, iron out all the creases and you're ready to print following the instructions overleaf. Once you have completed your pattern and the fabric is dry, set the paint by giving the tablecloth a long, gentle press with a dry iron on the highest temperature the fabric can take.

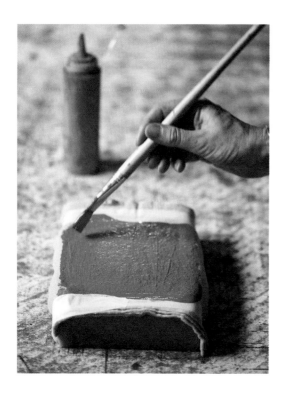

1. To print a tablecloth you will need a much larger work area. Ideally you want a table large enough to fit the width of the fabric, so you can print down the length.

2. Prepare the table (see page 124). If you're right-handed, position the fabric so that the top left corner is in the correct position for your first print. If you're left-handed, position the fabric in the top right corner. Pin the corners securely in place, then smooth the fabric out as flat as you can. Tuck any overhang neatly under the table – making sure you won't stand on it as you work. (I have a nifty shelf under the table in my studio that I use to gather the overhanging fabric.)

3. Prepare the printing pad. As this design is quite large, I created a printing pad using an old piece of foam sponge wrapped in a few sheets of wool felt. While it's important to create a pad with a 'springy' feel to allow the block to absorb the paint, it's best not to make the pad too thick – as it will simply absorb (and waste!) your paint.

4. Pour the paint into the bottle and dilute with water until you achieve a creamy consistency (see page 118). Shake the bottle well, remembering to keep your finger over the top. Gently squeeze the paint onto the pad. After making sure the pad is well and evenly covered in paint with the help of a paintbrush, load the block with paint. Starting in the top left corner, print your way across the width of the fabric.

5. Focus your mind as you continue the process again and again and again, loading your block with paint before every print. Repeat until the fabric in the print area is completely covered.

6. Next, gently and carefully move the printed fabric away from you – up and over the top of the print table – so you can continue printing down the length of the fabric.

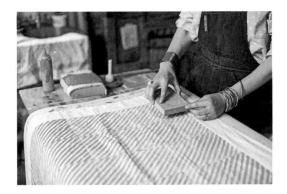

Be mindful that if the printed fabric is left to hang over the side of the table as you continue to work, your print may smudge when the tablecloth hits the floor. Try supporting the printed end of the tablecloth with a cardboard box, chair or bench to prevent unwanted additions (marks or blotches) to your design.

7. Continue printing until the tablecloth is fully covered.

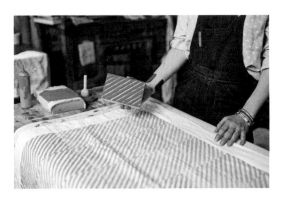

DESIGN NOTES

You might find that your block doesn't fit exactly within the edges of your tablecloth's hem. In these instances, I place a piece of paper over the hem so that when the block lands on top of it, it only prints in the centre of the cloth, leaving a plain hem behind.

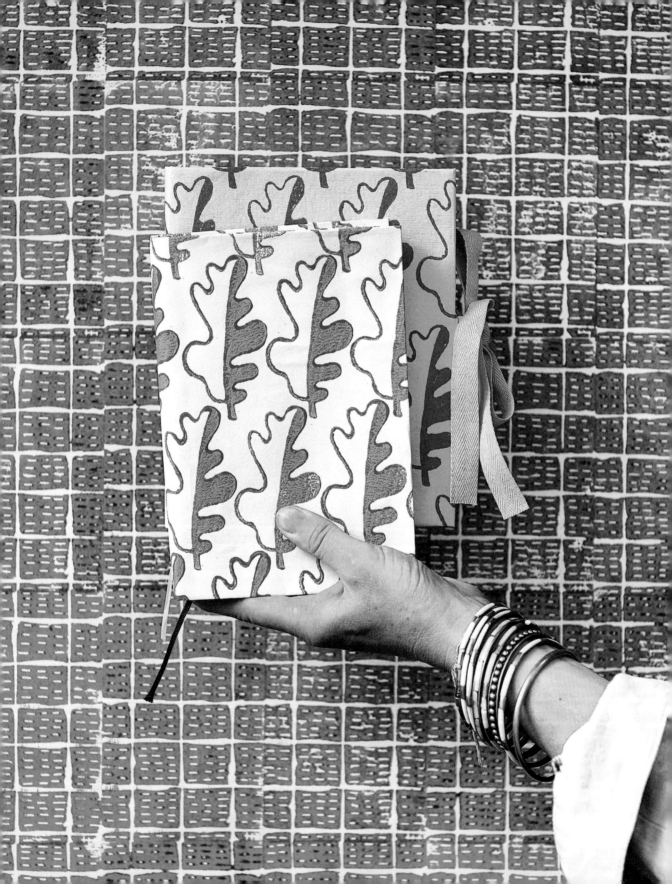

BOOK COVER

I started my business printing paper for stationery items. Printing onto large sheets is a great way to cover books, diaries, journals and notebooks – and to make something charming and unique in the process. When I'm in Jaipur, I have my designs carved into wood to create blocks like this oak leaf. You can buy a huge selection of beautiful wooden blocks online. They make fantastic ornaments when not in use.

table padding
old sheet
sheets of plain white
 paper – or paper of your
 choosing
plastic container with lid
 sheets of wool felt, as
 required, to create a
 'springy' printing pad
paint
plastic sauce bottle
paintbrushes
wooden block or carved
 lino pre-mounted onto
 a fibreboard block
book, diary, journal or
 notebook

You'll need to print onto a piece of paper that's large enough to wrap around your chosen book when closed, leaving an overhanging border of at least 5cm (2in) on all sides.

Once your printed paper has dried, place it print-side down and position your book in the centre of the paper. Fold the paper against the top and bottom edges of your book to create crease lines. Put the book to one side, then cleanly fold the paper along the top and bottom crease lines.

Gently smooth the paper flat (leaving the crease lines in place). Put the closed book on the right-hand side of the folded paper, 5cm (2in) away from the side edge. Wrap the left-hand side of the paper over the front cover of your book and make a crease along the side edge of the front cover.

Remove your book and cleanly fold the side crease. Fold the side, top and bottom creases down to create the front sleeve, and slide the front cover of your book inside. When the front cover is in place, cut away a V-shaped section from the hinge at the top and bottom of the book (this will allow you to fold the paper neatly over the front and back covers). Close the book again and make a crease against the side edge of the back cover. Remove your book and cleanly fold the crease. Fold the side, top and bottom creases down to create the back sleeve. Slide the front and back covers into position and tape or glue the paper into place, if required.

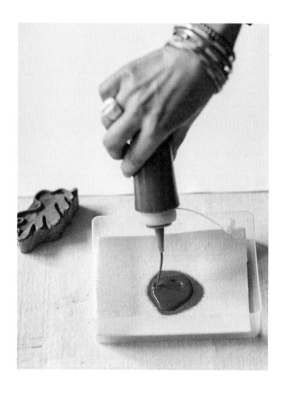

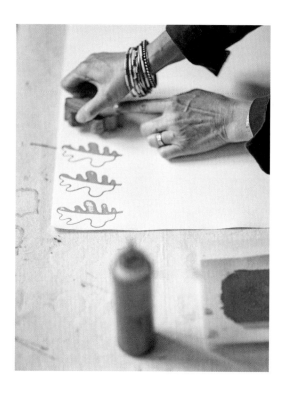

1. Place your sheet of paper over the prepared printing table (see page 124) and gently smooth it flat with your hands.

2. Create a paint tray using a plastic container and wool felt for the printing pad.

3. Pour the paint into the bottle and dilute with water until you achieve a creamy consistency (see page 118). Shake the bottle well, but remember to keep your finger over the top. Gently squeeze the paint onto the pad and use a paintbrush to create an area slightly larger than your block.

4. Once the paint has soaked into the felt, place the block onto the pad, then lift it off the paint.

5. If you're right-handed, position the block in the top left corner of the paper and CONFIDENTLY give it a good push down. Take a breath and lift it away. Print from left to right in straight lines, placing the block directly to the right of the last print. Work in the opposite direction if you are left-handed. Remember to load your block with paint before every print.

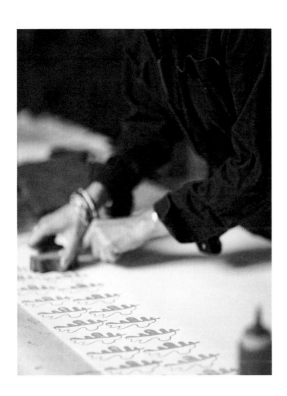

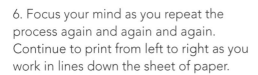

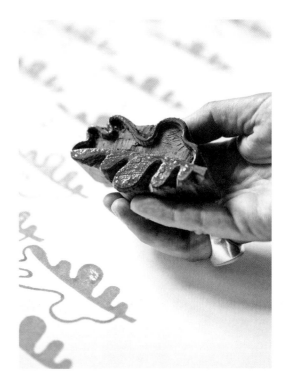

6. Focus your mind as you repeat the process again and again and again. Continue to print from left to right as you work in lines down the sheet of paper.

Remember to think about your vertical and horizontal lines and your use of negative space as your pattern grows. Here, to make the pattern more interesting, I offset each new line to fill the negative space created by the previous print line.

7. Repeat the print until your sheet of paper is completely covered.

DESIGN NOTES

You may want to think about how your print will work across the size of your book before you start printing, so you can adjust the pattern accordingly.

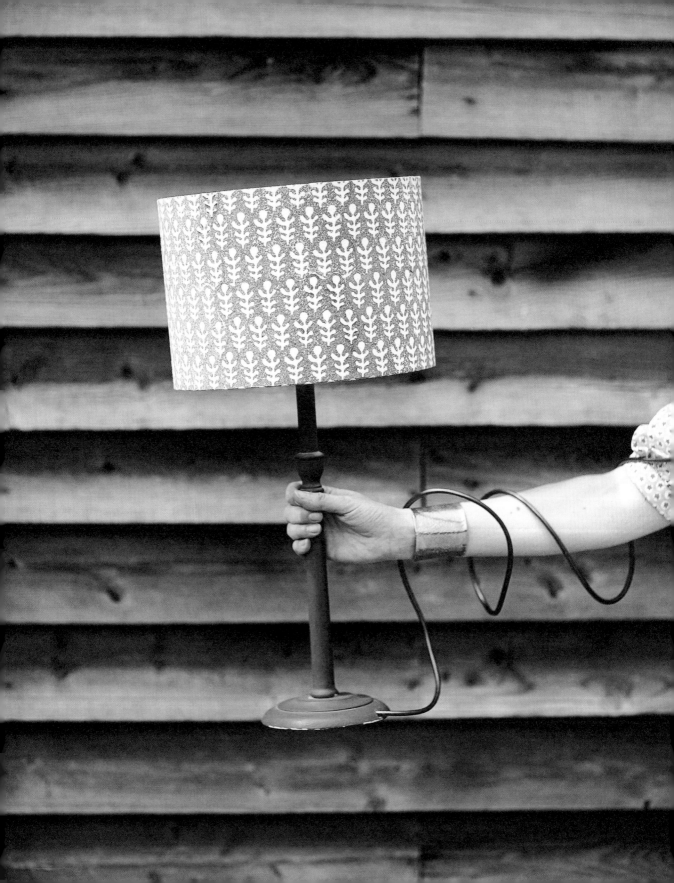

LAMPSHADE

One of the favourite things we make as a company is our lampshades. You can get nifty lampshade making kits online now or you can make a simple little gathered cover to dress an existing shade (see page 148) – it's an instant and extremely gratifying alteration! This shade has been printed using a traditional Indian wooden block featuring our Bagru design.

table padding
old sheet
plain fabric or fabric from lampshade kit
pins
fabric paint
plastic sauce bottle
block of wood
sheets of wool felt, as required, to create a 'springy' printing pad
paintbrushes
Indian block or carved lino pre-mounted onto a fibreboard block

If you're using a lampshade kit, print across your chosen fabric. When the paint is set, follow the manufacturer's instructions to create your shade.

You don't need much fabric to create a gathered cover to dress an existing shade, so source some old linen at an antiques market, transform an old sheet, or buy some plain, off-white fabric. Wrap the fabric to be printed around the lampshade you wish to cover to find the length and width measurements. To this calculation, increase your length measurement by between ¼ and ½ again, depending on the fullness of the gather you are looking to achieve. Finally, add an additional 3cm (1¼in) hem allowance to all sides. Cut your fabric to size and print.

When the fabric is completely dry and the paint is set, sew the hem down the two shorter, side edges and along the bottom edge. Hem along the top edge, adding an extra channel below the hem to feed a piece of ribbon through. Thread the ribbon through the channel, leaving an allowance at both ends to fasten the shade together. Position the fabric over the shade, gather as desired, and tie the ribbon to secure in place at the top.

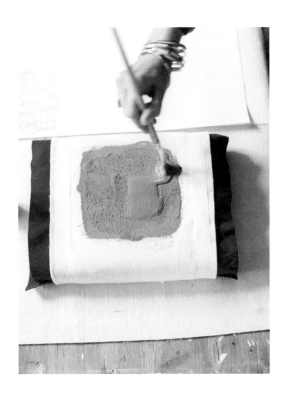

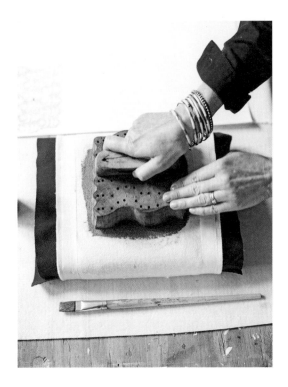

1. Prepare the table (see page 124). If you're right-handed, position the fabric so that the top left corner is in the correct position for your first print. If you're left-handed, position the fabric in the top right corner. Pin the corners in place, then smooth the fabric out as flat as you can.

2. Prepare the printing pad. As the design is quite large, here I made a really good printing pad using a large block of wood wrapped in a springy layer of wool felt.

3. Prepare the paint (see page 118). Gently squeeze the paint onto the pad and use a paintbrush to create an area slightly larger than the block.

4. After making sure the pad is well and evenly covered, load the block with paint.

5. If you're right-handed, carefully position the block in the top left corner of the fabric and CONFIDENTLY give it a good push down. Take a breath and lift it away.

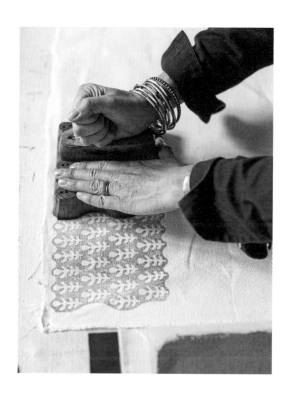

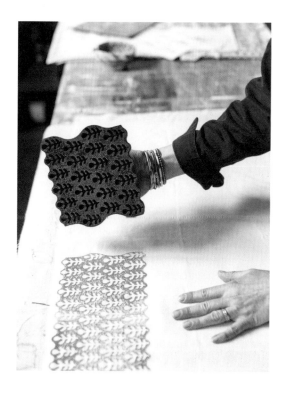

6. Repeat the process, moving along the line from left to right, and loading your block with paint before every print. (If you're left-handed, work in the opposite direction.)

7. Repeat the print until your fabric is completely covered.

DESIGN NOTES

The trick here is to work with the shape of the wooden block (in this case, its curved edges) to achieve a seamless effect. Take your time and remember confidence is key.

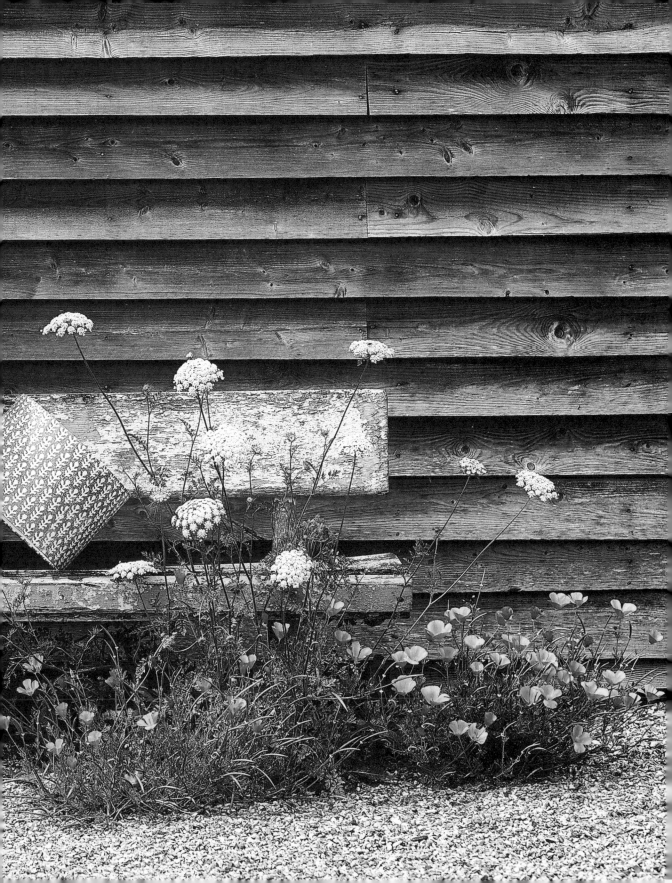

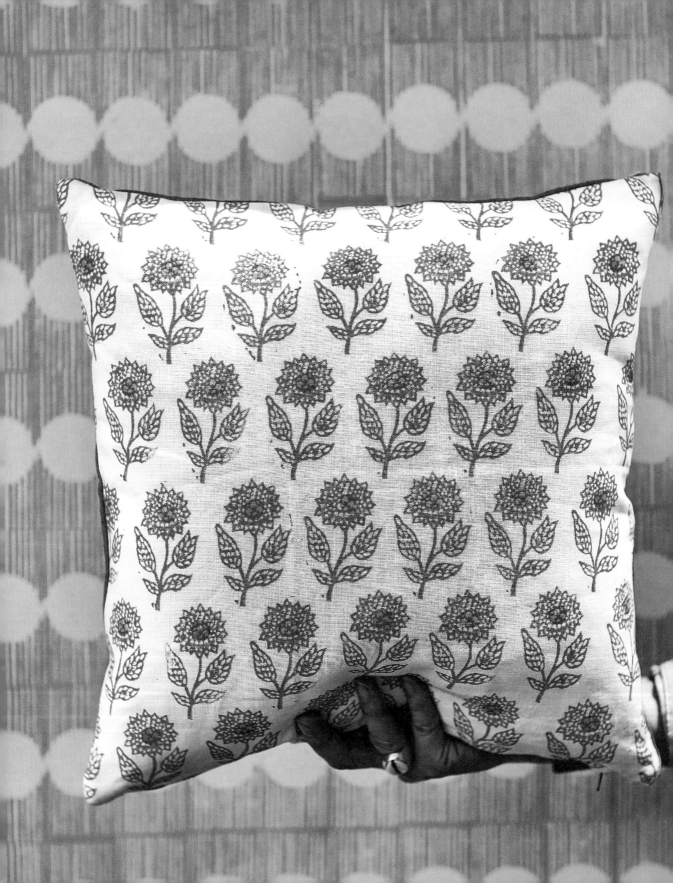

CUSHION

There is something incredibly rewarding about seeing your piece of block-printed fabric made up into a cushion or pillowcase. They make a fantastically generous present for someone special, or allow you to add a real piece of homespun charm to your own home. This particular project also shows you how to layer up colours.

table padding
old sheet
fabric or plain
 cushion cover
pins
sheets of wool felt, as
 required, to create a
 'springy' printing pad
2 plastic containers
 with lids
fabric paints
2 plastic sauce bottles
paintbrushes
wooden block or carved
 lino pre-mounted onto
 a fibreboard block
stick or cane

It's possible to buy plain cushion covers that you can print on. Alternatively, it's simple to make a square cushion cover once your printed fabric is dry and the paint is set.

You can print onto a length of fabric before cutting out your cushion cover, but remember to leave a healthy allowance on all sides for the seams. Alternatively, you can print directly onto your prepared cushion pieces.

To make a cushion cover, measure the size of the cushion pad, adding at least 5cm (2in) seam allowance on all sides. Cut two squares from your printed fabric and press, then pin the squares right-sides together.

Machine stitch around three sides (remember to remove the pins as you go). If you have an overlocker, overlock the edges. If you don't, simply trim off the excess fabric and zigzag stitch the edges. Turn the cover right-side out. Turn the unsewn edges in and press.

Insert your cushion pad and pin the open seams together. Sew along the final edge with a sewing machine or stitch the edge by hand.

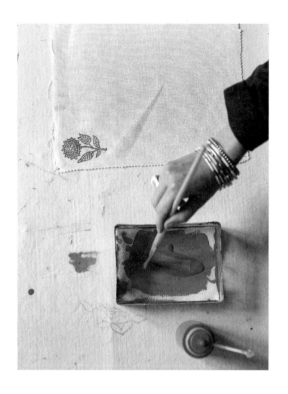

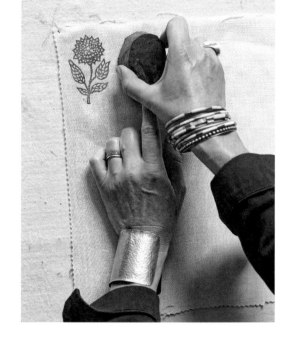

1. Place your fabric flat over the prepared printing table (see page 124). Use pins to secure the corners in place. Smooth out any creases as you work.

2. Create a paint tray using a plastic container and wool felt for the printing pad.

3. Pour the paint into a bottle and dilute with water until you achieve a creamy consistency (see page 118). Gently squeeze the paint onto the pad and use a paintbrush to create an area slightly larger than your block. Once the paint has soaked into the felt, place the block onto your printing pad. Lift the block off the paint and start printing.

4. If you're right-handed, work in lines from left to right, starting in the top left corner (work in the opposite direction if you're left-handed). CONFIDENTLY place the block down onto the fabric and give it a good push. Take a breath and lift the block – do not hesitate! Repeat the process along the fabric, loading your block with paint before every print.

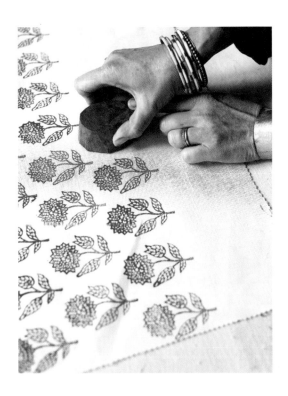

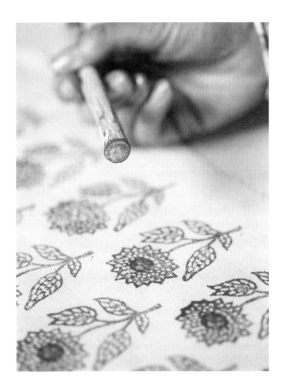

5. Focus your mind as you continue the process again and again and again… repeating the print until your piece of fabric is completely covered. Remember to think about your vertical and horizontal lines and your use of negative space as your pattern grows. Leave to dry.

DESIGN NOTES

While your design will be printed flat onto the fabric, once your cover is placed over the cushion pad the pattern will be given so much life – the pad also hides any areas where your design may have 'wobbled'.

6. Once your block pattern has completely dried, create another printing pad inside the second plastic container and prepare with a contrasting colour of fabric paint (following the advice from Step 3).

7. Using the end of a wide stick or piece of bamboo cane, accent your original print until you have a beautiful, two-colour, contrasting design.

MORE PRINTING PROJECTS

While I've walked you through a few of my favourite items to make, when it comes to printing I say, if it will take the paint, print it!

You can create so many wonderful pieces to decorate your home, from napkins and cushions, to framed prints and tea towels. If you're in the mood for a challenge, why not try block printing curtains – this involves the demanding requirement of printing long continuous lengths of fabric. If you do take on the curtain challenge, take your time. Don't expect to print them in one day. Unless you have a lovely, airy barn or workspace, you will have to stop once you've printed a few metres to let them dry, then you can fold the printed fabric under the table and carry on.

Why stop at homeware? You could create fashion pieces like scarves, T-shirts, or handkerchiefs and pocket squares for special occasions. You could even try printing a pair of jeans!

One of the greatest joys of block printing is its huge gifting potential – think of all the unique, thoughtful things you could make for someone special. Why not go the extra mile and print some wrapping paper to match? There is nothing more cheery or more heartfelt than a piece of hand-printed wrap – or even a simple, printed card. It also feels good (and saves money) to have made your own. At Christmas, I buy rolls of recycled brown paper and the children and I go to town. You can print very accurately or you can totally free print.

With a little stamp you can also print lengths of ribbon, which provides a really lovely finishing touch. You can be sure that your printing efforts will not be thrown in the bin by the recipient, but treasured alongside their gift.

HAPPY PRINTING EVERYONE

TEMPLATES

If you don't feel confident enough to start with one of your own designs, here are some templates you can trace and carve into your lino or rubber block. You could scale the templates up or down as you wish using a photocopier. Alternatively, download the templates from: **www.pavilionbooks.com/book/house-of-print**

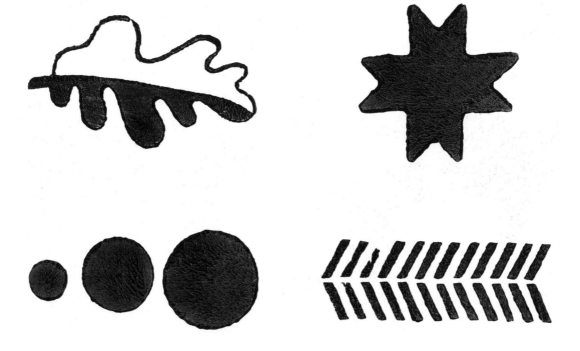

RESOURCES

Supplies

The Clever Baggers for pre-made, ready-to-print items.
www.thecleverbaggers.co.uk

The Cloth Shop for lovely linens.
www.theclothshop.net

Dannells for lampshade making kits
www.dannells.com

Jackson's Art Supplies for all sorts of paints.
www.jacksonsart.com

Lawrence for lino and tools.
www.lawrence.co.uk

Permaset paints for eco-friendly printing.
www.permaset.com.au

Shepherds for lovely pencils and paper.
www.store.bookbinding.co.uk

Inspirational places

Charleston Farmhouse, East Sussex
www.charleston.org.uk

The Lost Gardens of Heligan, Cornwall
www.heligan.com

Isle of Mull, Scotland
www.visitscotland.com/destinations-maps/isle-mull/

Petersham Nurseries, London
www. petershamnurseries.com

South Downs National Park
www.southdowns.gov.uk

Victoria and Albert Museum, London
www.vam.ac.uk

Jaipur highlights

To see
Brigitte Singh
www.brigittesingh.com

Anokhi Museum
www.anokhi.com/museum/home.html

Phool Mandi, Wholesale Flower Market
(go early morning)

The village of Bagru, a block printer's heaven

To stay
Jobner Bagh
www.jobnerbagh.com

Kothi 28
www.28kothi.com

To eat
Bar and café Palladio
www.bar-palladio.com

The café at the Jaipur Modern
www.jaipurmodern.com/cafe

ACKNOWLEDGEMENTS

The biggest thank you…

To everyone at Pavilion who has supported, helped me, and put up with me during the amazing journey of bringing this book together.

To Kristin, for nailing every image and understanding instantly what I wanted to achieve.

To my dearests friends Lisa and Toby for so generously sharing their idyllic home, Hawthbush Farm, and allowing us to take so many of the images there.

To my sister Emma Lewis, brother-in-law James Mahon, and photographer Jonas Spinoy, who have accompanied me on my Jaipur adventures and taken some of the images included in the India section.

To Cath Kidston, one of my very first clients (which in itself was a huge confidence boost), who became my mentor and friend. Cath is one of my heroes and I am so grateful for her support.

To all our loyal customers, who have given me the confidence and belief in growing our little homespun business, and to all those who love colour and pattern as much as I do.

To Jaipur for your energy, colour and endless possibility.

To all female block printers and designers who have inspired me to make this an important part of my life.

To Vanessa Bell, whose bohemian artistic life has shown me that you can break the rules and express yourself as the person you truly are.

To my wonderful family and friends for all your support and encouragement. To my dear, patient, unbelievably proud and supportive husband, Rollo. And to my children, Lani, Algie and Orlando, who I love and admire and who inspire me every day.

First published in the United Kingdom in 2020 by
Pavilion
43 Great Ormond Street
London
WC1N 3HZ

ISBN 978-1-91164-122-3

A CIP catalogue record for this book is available from the British Library.

10 9 8 7 6 5 4 3 2 1

Reproduction by Rival Colour Ltd, UK
Printed and bound by Toppan Leefung Printing Ltd, China

www.pavilionbooks.com

IMPORTANT SAFETY NOTICE

Using cutting tools to work with lino, rubber, wood and other materials inherently includes the risk of injury and damage. We cannot guarantee that creating the projects in this book is safe for everyone. For this reason, this book is sold without warranties or guarantees of any kind, expressed or implied, and the publisher and the author disclaim any liability for injuries, losses or damages caused in any way by the content of this book or the reader's use of the tools needed to complete the projects presented herein. The publisher and the author urge readers to thoroughly review each technique and project and to understand the use of all tools before beginning any project.

Book design by **NATHAN GRACE**.

Photography taken by **KRISTIN PERERS**.

Additional photography by:

EMMA LEWIS pages 27, 30–1, 37, top left and right, 38, 41, 43, 45, 46 top and bottom left, 52–3, 56–7, 58 right, 59–60.
www.emmalewis.xyz/
Instagram @emmalewisphotographer

MOLLY MAHON pages 25, 29, 30 top and far left, 31 top and far right, 32, 35, 37 bottom left and right, 39, 42, 46 bottom right, 49, 51, 58 left, 61.

PRITI PUGALIA page 17.

JONAS SPINOY pages 50, 55, 127.